BARNS
of the
GREAT AMERICAN WEST

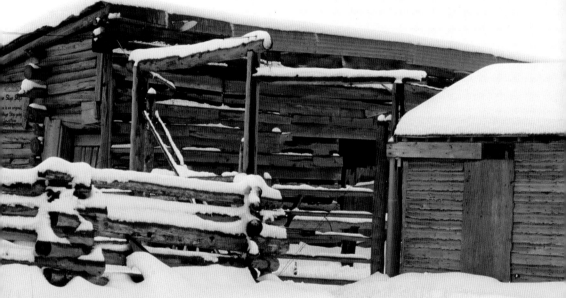

Ranch
daho

Photography by David R. Stoecklein

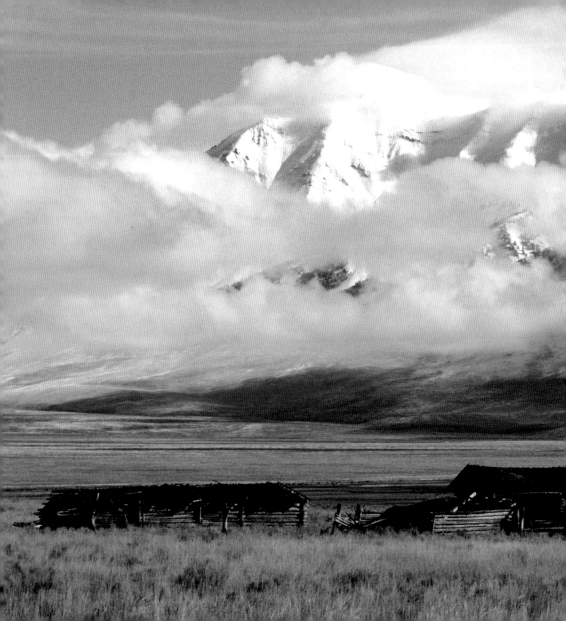

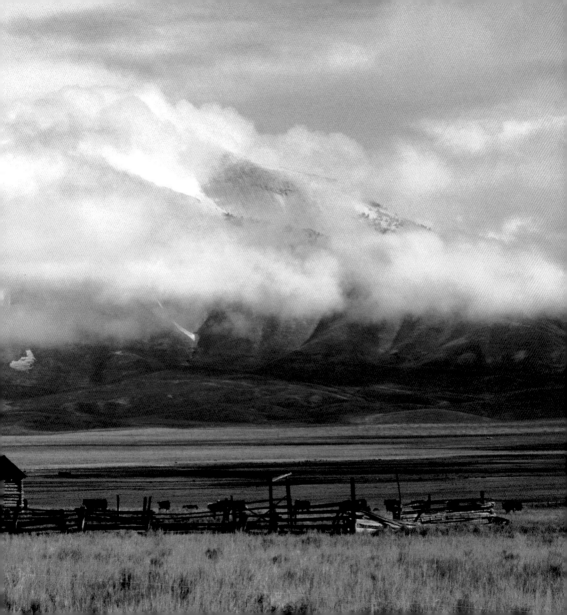

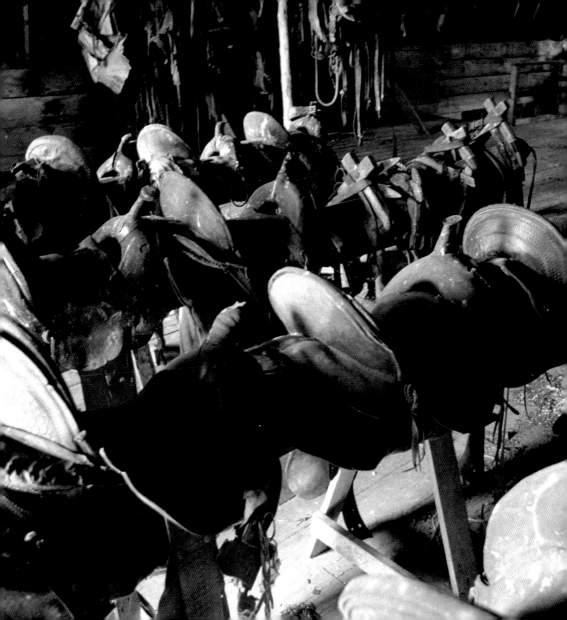

BARNS
— of the —
GREAT AMERICAN WEST

Photography David R. Stoecklein
Editor Carrie Lightner
Creative Director David R. Stoecklein
Art Direction & Design Sarah Snyder

Other books by Stoecklein Publishing include *The Cowboy Hat, Fly Fishing in Idaho, The American Quarter Horse, Cattle, The Cowboy Boot, Outhouses, Western Fences, Saddles of the West, California Missions, Dude Ranches of the American West, The Spur, The Western Buckle, Ranch Style, Cowgirls in Heaven, The Performance Horse, Cow Dogs, Lil' Buckaroos, The American Paint Horse, The Idaho Cowboy, Cowboy Gear, Don't Fence Me In, The Texas Cowboys, The Montana Cowboy, The Western Horse, Cowgirls, Spirit of the West,* and *The California Cowboy.*

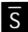

Stoecklein Photography & Publishing
1730 Lear Lane, Unit A
Hailey, Idaho 83333
tel 208.788.4593 fax 208.788.4713 toll-free 800.727.5191
WWW.THESTOECKLEINCOLLECTION.COM

Printed in China
Copyright © 2006 Stoecklein Publishing

ISBN-10: 1-933192-62-3
ISBN-13: 978-1-933192-62-8
Library of Congress Catalog number 2005910278

Old sheep herder and cowboy saddles
Matador Ranch
Dillon, Montana

Previous page:
Broken Dreams
Abandoned Ranch
Chili, Idaho

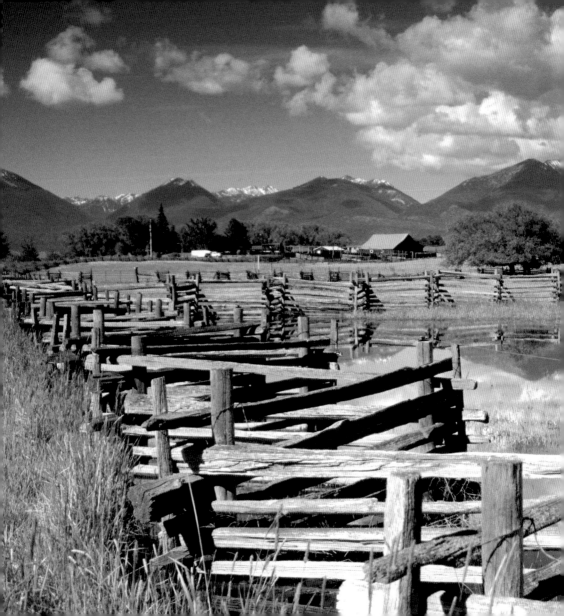

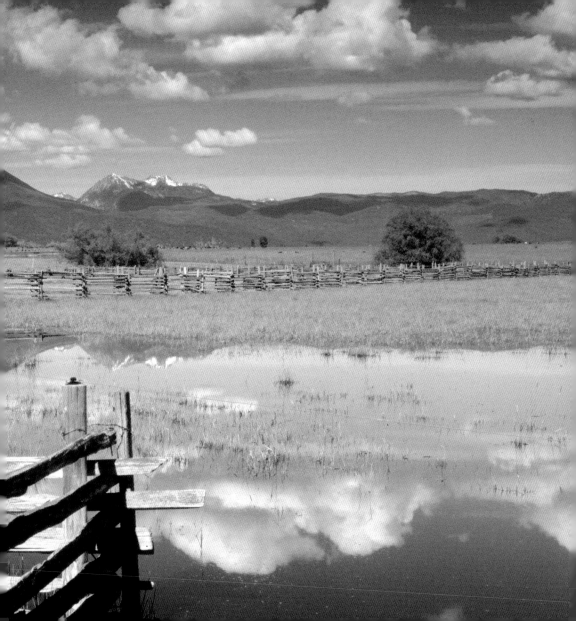

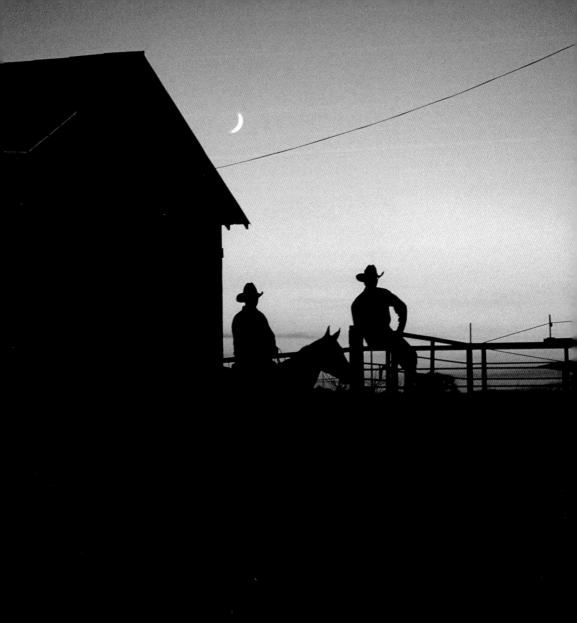

Foreword

The Western barn is fundamentally different from its eastern US and European cousins. Most of the barns in Western states are made from native lodgepole pine trees or stone and rock gathered from nearby streams and mountains.

When settlers first arrived in the West, the first building they usually built was the barn. Winter came quickly, and they had to build shelter for the animals that would help them start a new life. The oxen that pulled the wagons, along with sheep and pigs, would be the food and the breeding stock. These brave individuals often shared the barn that first winter with the animals.

The barn usually became the center of life on the ranch. Later, with the ranch's growth and success, the barn grew. Sometimes a team of barn builders arrived and they moved around the West, signing up clients and building barns. The barns in the valleys where the men worked are similar on many ranches. These barns usually reflected whether the builder came from back East or Europe. Many ranchers purchased barns from the Sears Catalog and had them shipped West on the train and freighted on horse-drawn wagons to distant valleys.

There is an entire culture centered around barns. I hope this small book will give you an idea of the different styles and shapes of barns throughout the American West. This book is one in a series I have published with the intention of preserving the West as it is today. I hope you learn a little bit about barns, Western culture, and the lifestyle of the West.

—David R. Stoecklein

Day's End
Veale Ranch
Breckenridge, Texas

Previous page:
Wilson Livestock headquarters
North Powder, Oregon

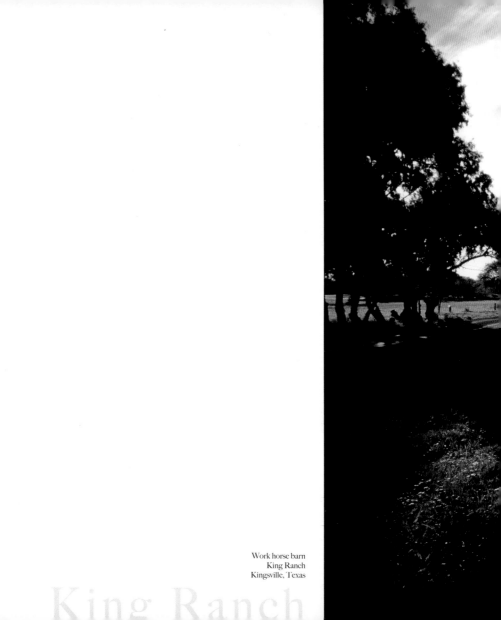

Work horse barn
King Ranch
Kingsville, Texas

King Ranch

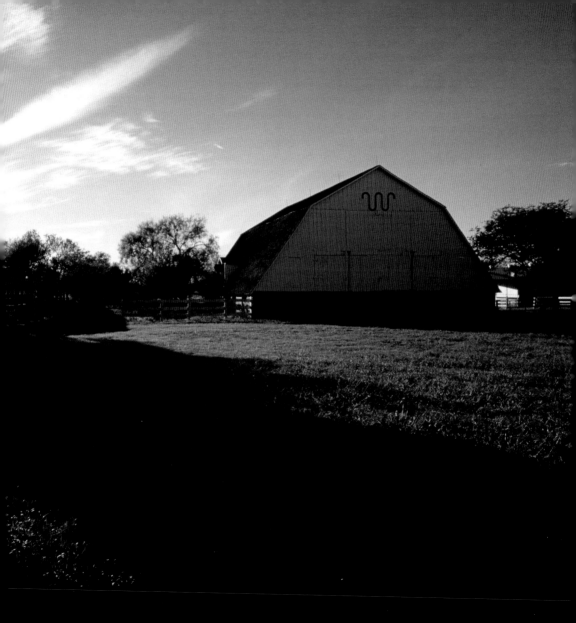

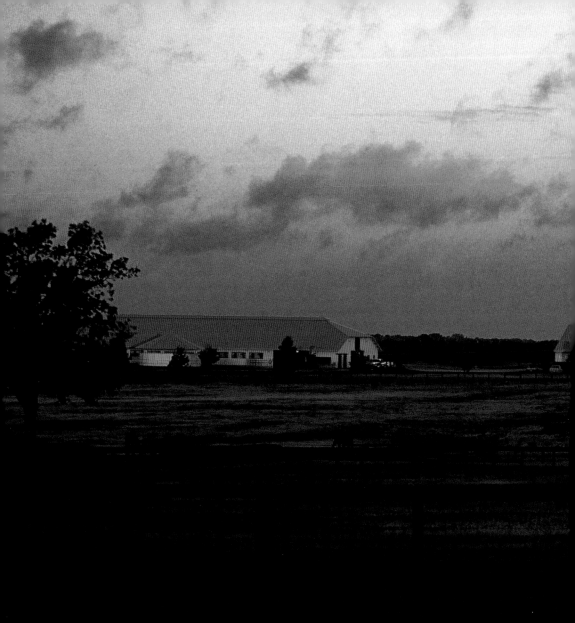

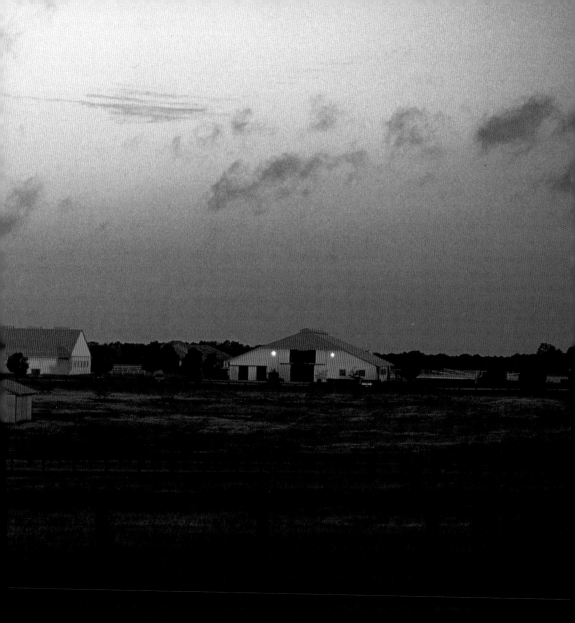

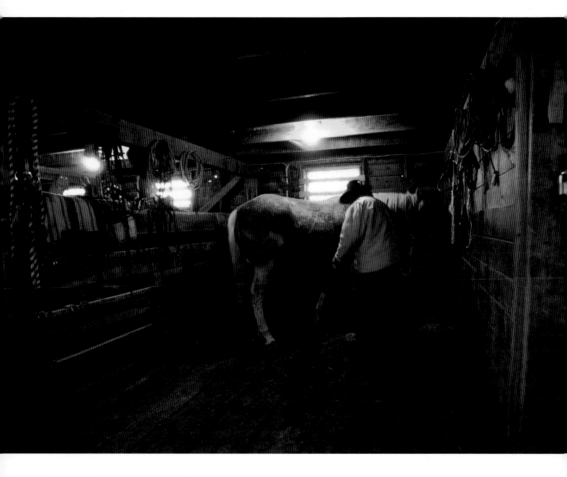

Saddling Up
Selkirk Ranch
Dillon, Montana

Selkirk Ranch

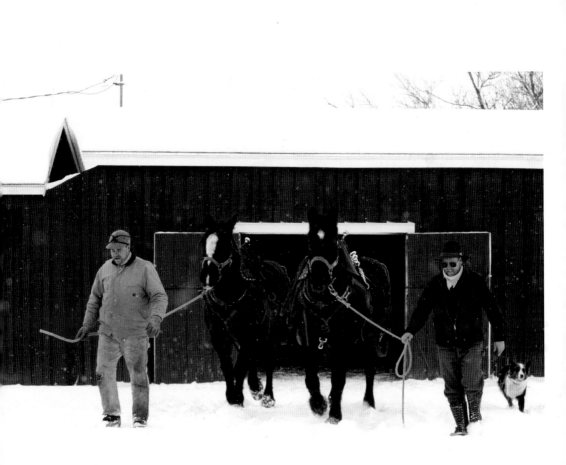

Work horse barn
Bitterroot Stock Farm
Hamilton, Montana

Bitterroot Stock Farm

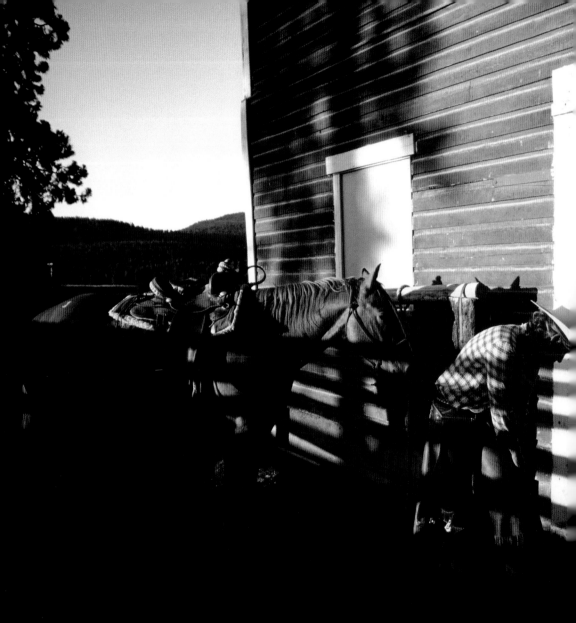

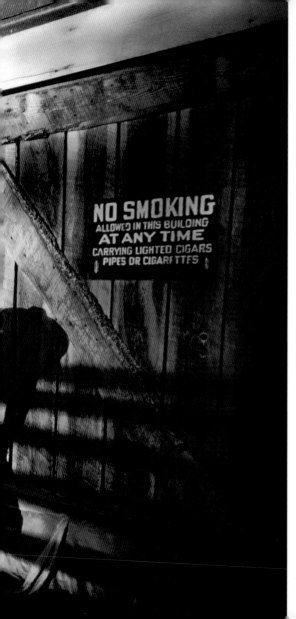

IN THE BEGINNING,
THE ONLY PLACE YOU
COULDN'T SMOKE
WAS THE BARN.

Three Bars Cattle & Guest Ranch
Cranbrook, British Columbia

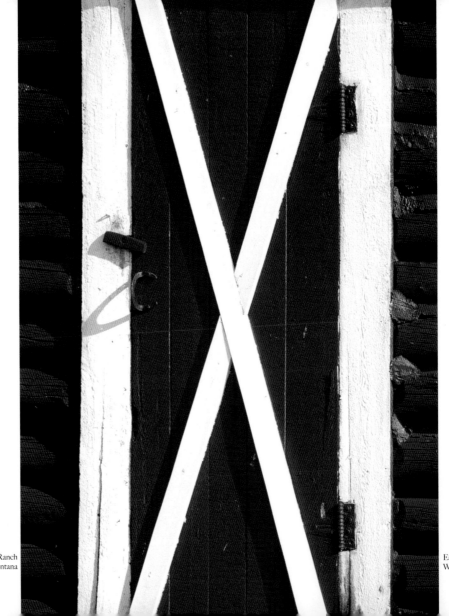

Horse Prairie Guest Ranch
Horse Prairie, Montana

Eatons' Guest
Wolf, Wyom

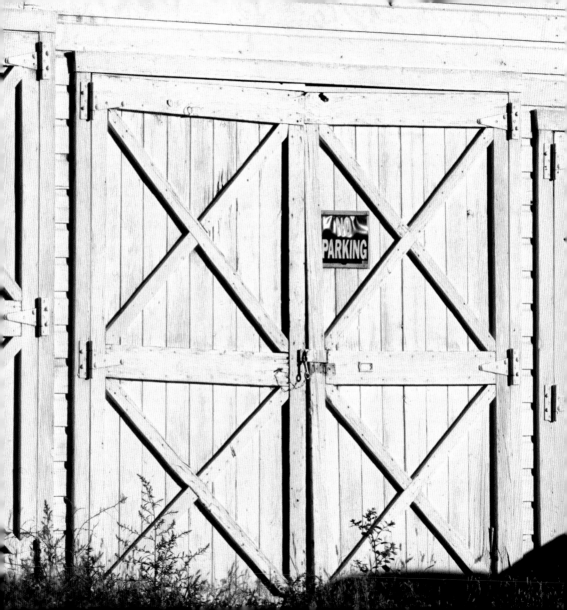

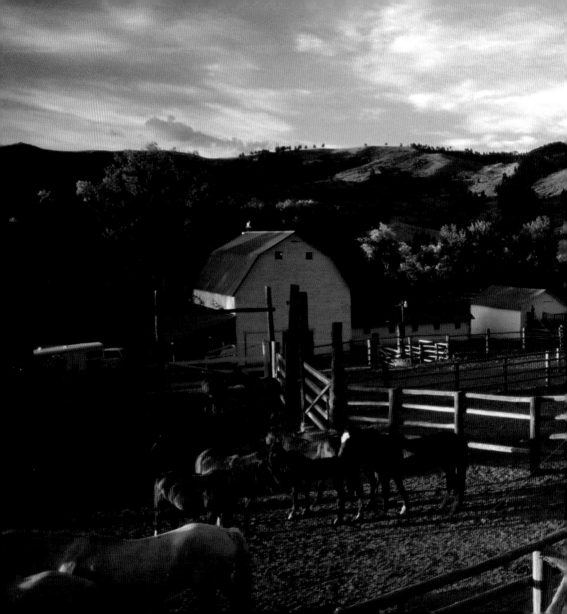

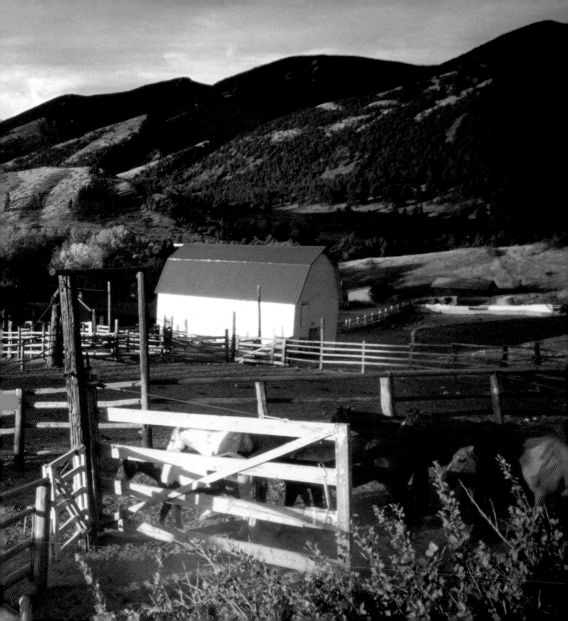

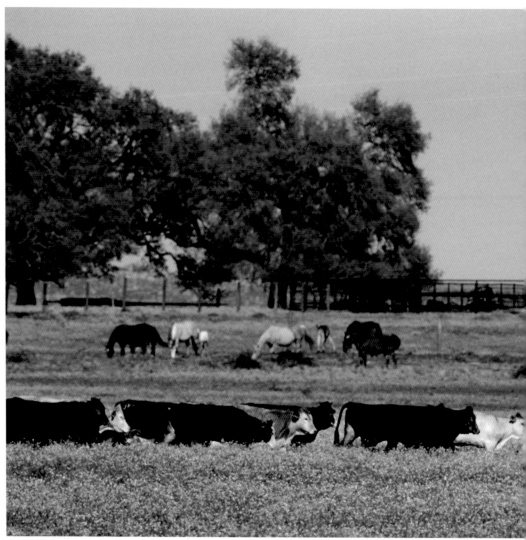

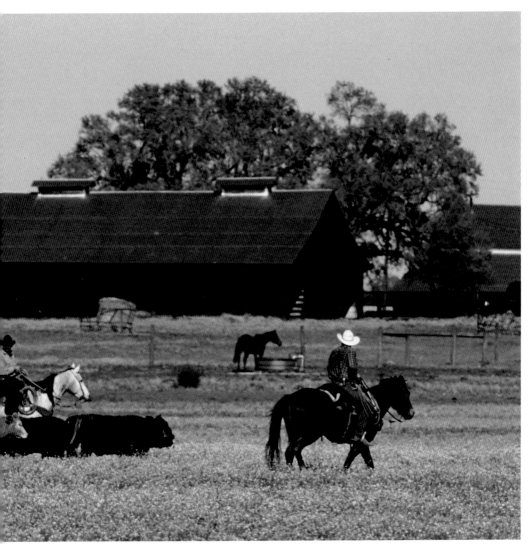

Gray Ranch
Vinton, Louisiana

A Little Grain
Horse barn
Jalama Ranch
Lompoc, California

Evening Light
Horse barn
Jalama Ranch
Lompoc, California

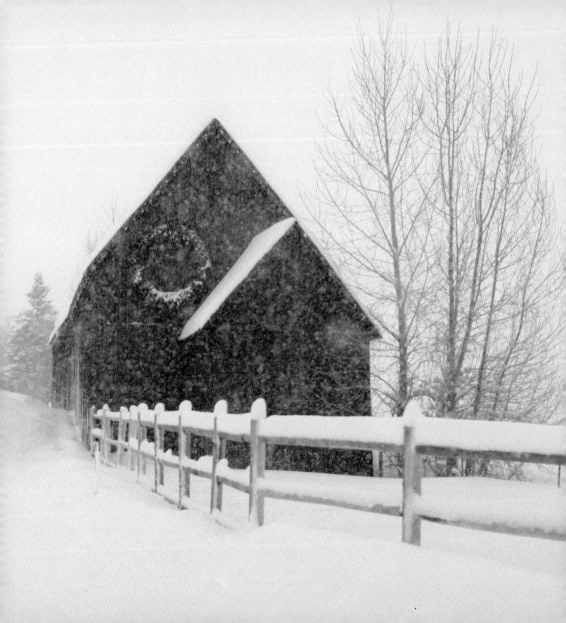

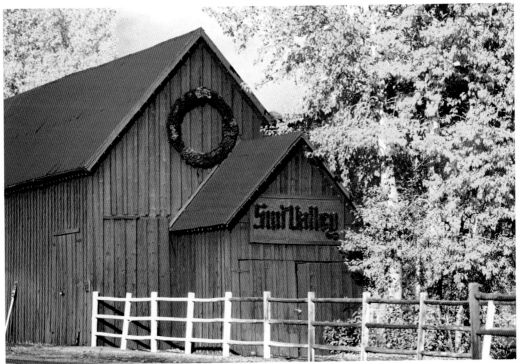

Old milk barn
Sun Valley Ranch
Sun Valley, Idaho

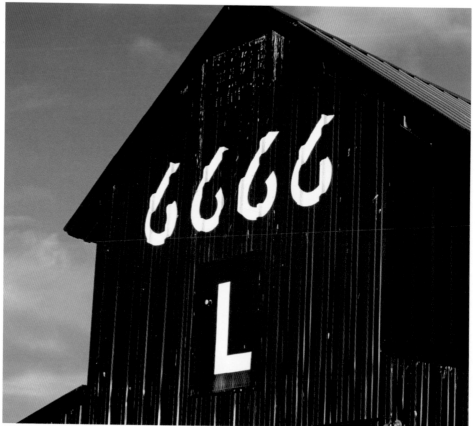

West Texas Icon
6666 Ranch barn
Guthrie, Texas

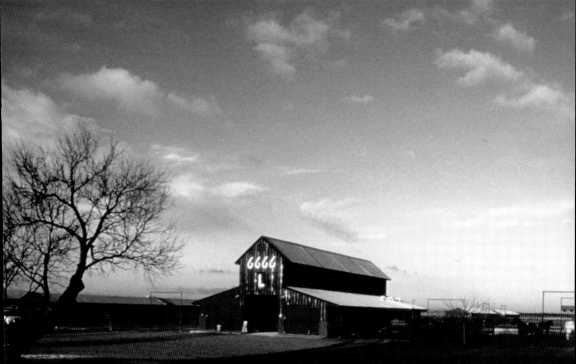

Livery stable
King Ranch
Kingsville, Texas

King Ranch

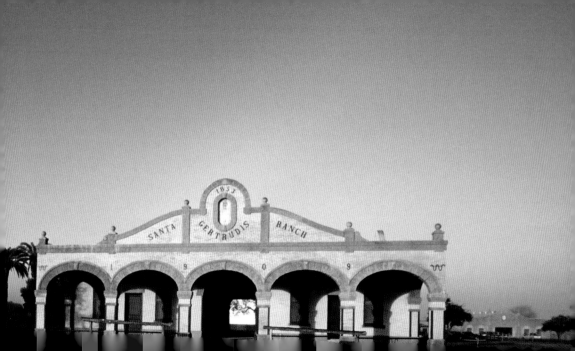

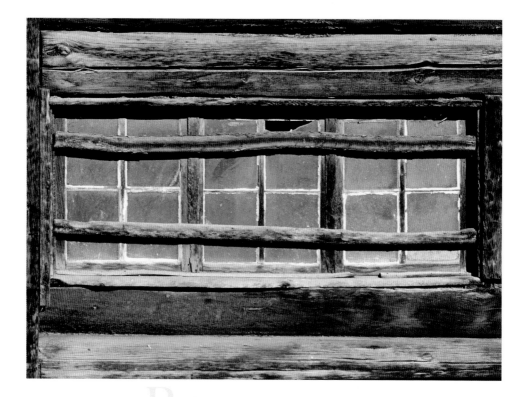

THESE BARS ARE TO KEEP
HORSES FROM STICKING
THEIR HEADS THROUGH THE
GLASS IN ORDER TO GET TO
THE GRAIN.

Elkhorn Guest Ranch
Gallatin Gateway, Montana

Great View
Bar 13 Ranch
Mackay, Idaho

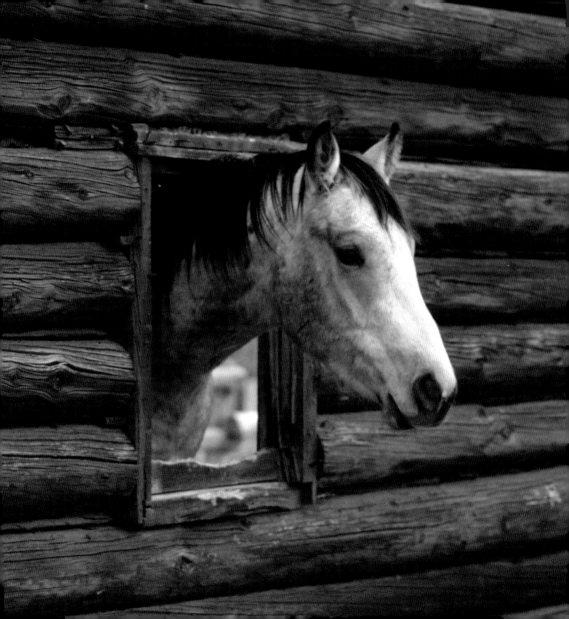

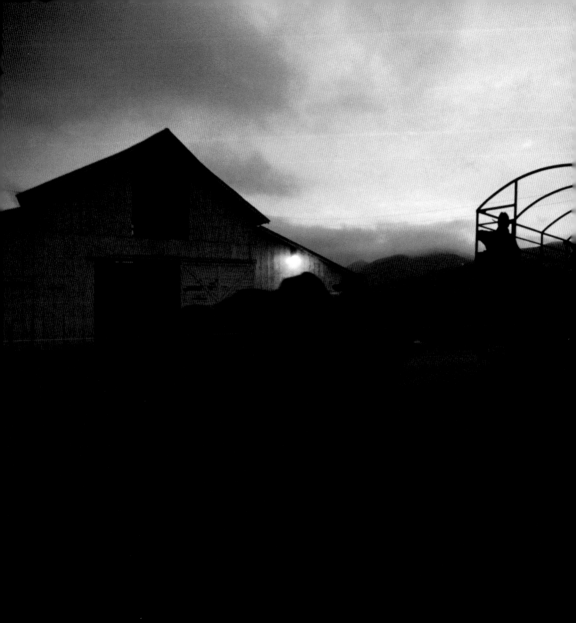

Loading Up
Yokohl Valley Ranch
Yokohl Valley, California

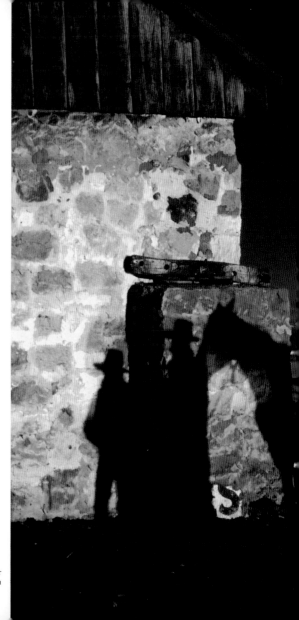

Jim and Mindy Kershner
Jordan Valley, Oregon

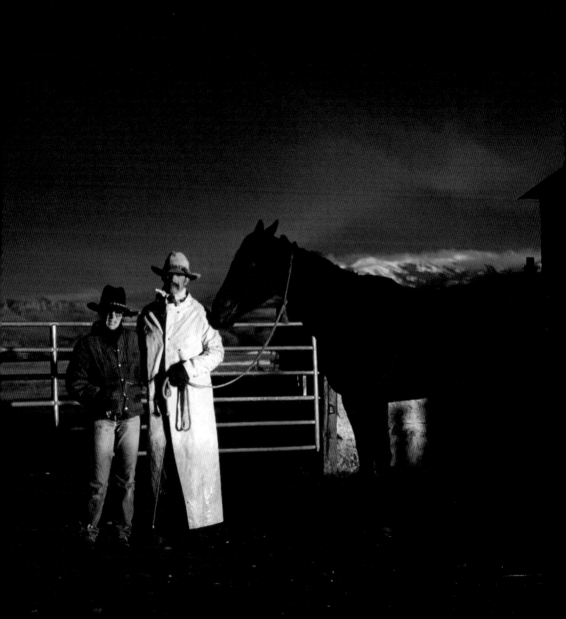

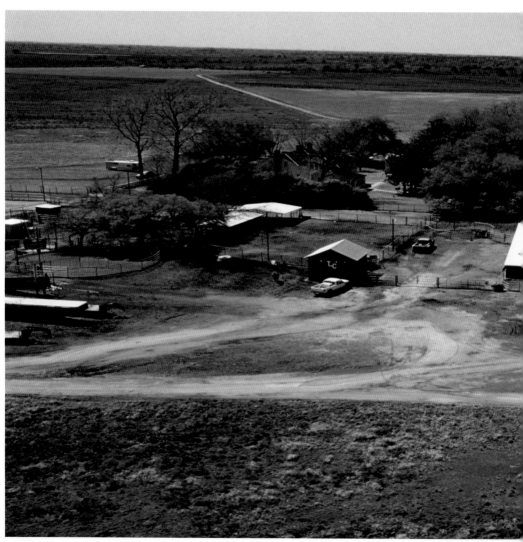

Barnyard
Gray Ranch
Vinton, Louisiana

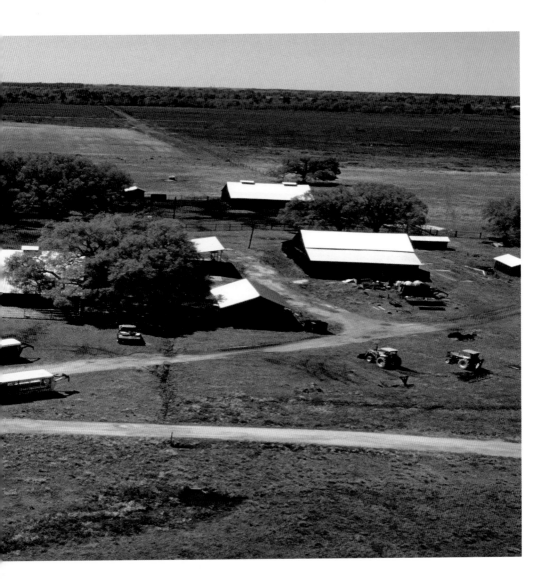

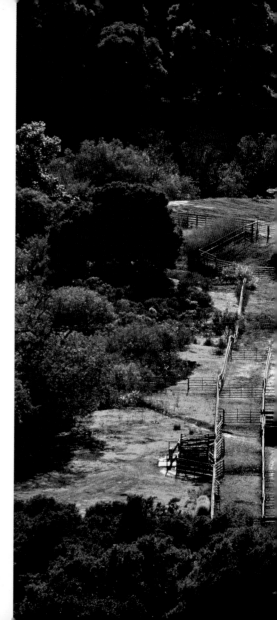

THE BARNYARD IS
WHERE THE HORSES ARE
FED AND BROKE. IT IS
WHERE THE CATTLE ARE
BRANDED AND SORTED.
IT IS WHERE THE NEW
CATTLE ARE OFF-LOADED
AND FIRST INTRODUCED
TO THE RANCH. IT
IS WHERE THEY ARE
SHIPPED OUT ON THEIR
LAST DAY ON THE RANCH.

Barnyard
Jalama Ranch
Lompoc, California

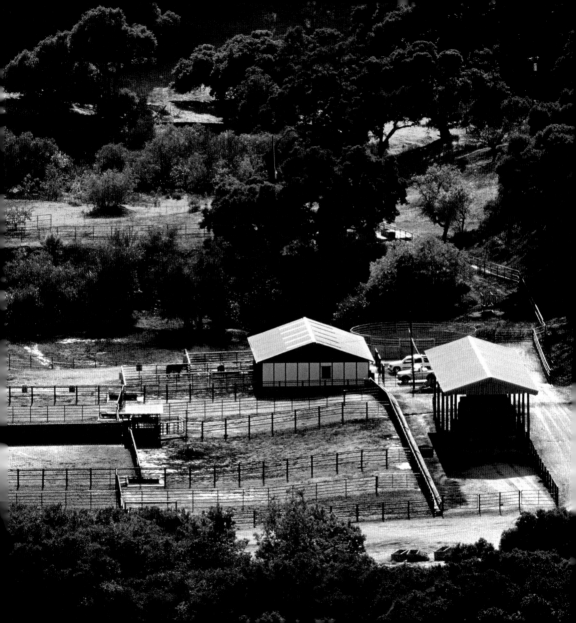

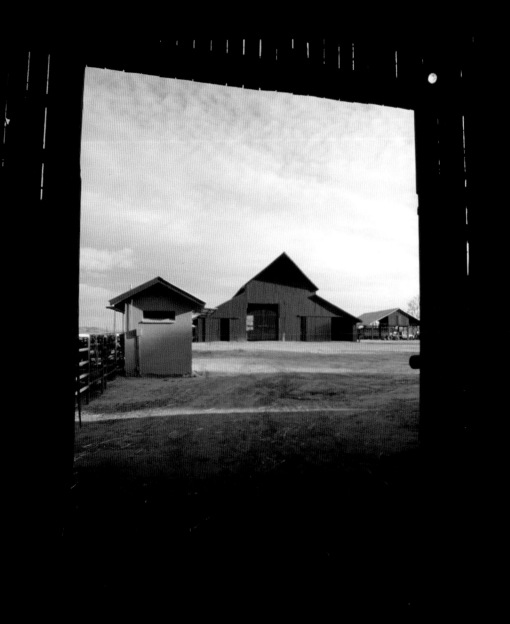

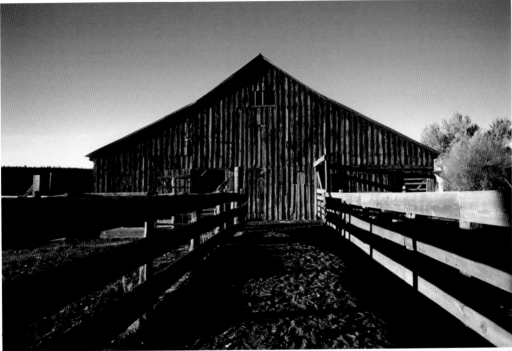

Flournoy Ranch
Likely, California

Scales and work barn
Jack Ranch
Paso Robles, California

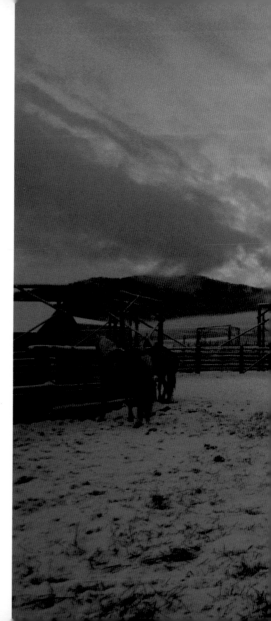

Old Signs

RANCHERS OFTEN HANG
OLD SIGNS ON THE
SIDES OF THEIR BARNS.
MOST LIKELY, THIS
PEGASUS MUST HAVE
SOME MEANING TO WALT
VERMEDAHL OTHER
THAN AS A GASOLINE
LOGO.

Frosty Morning
Vermedahl Ranch
Polson, Montana

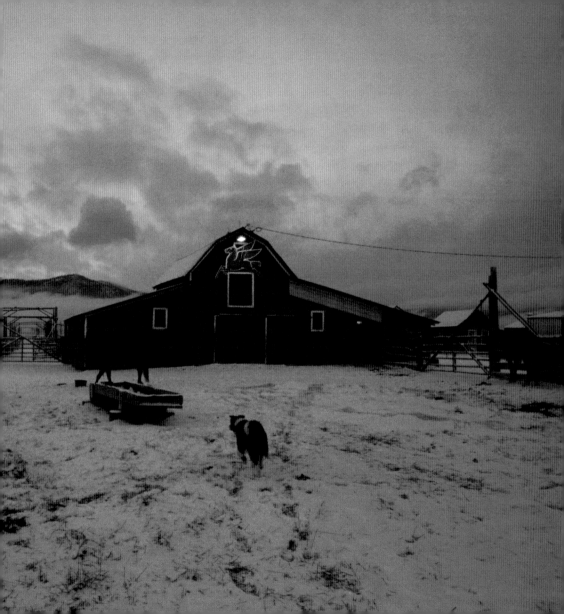

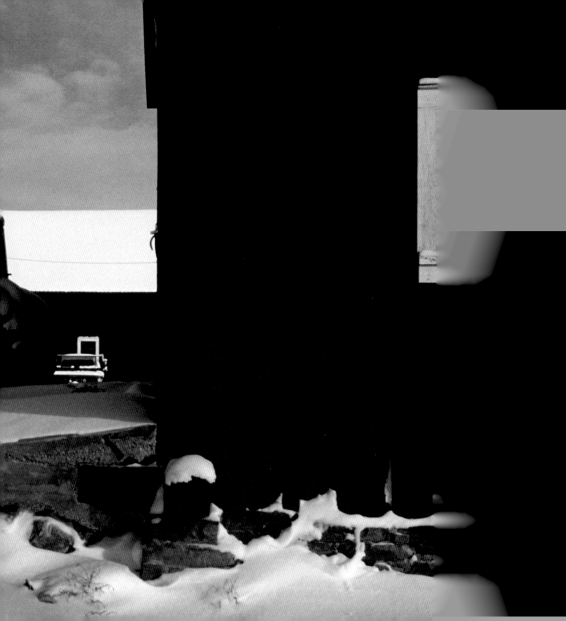

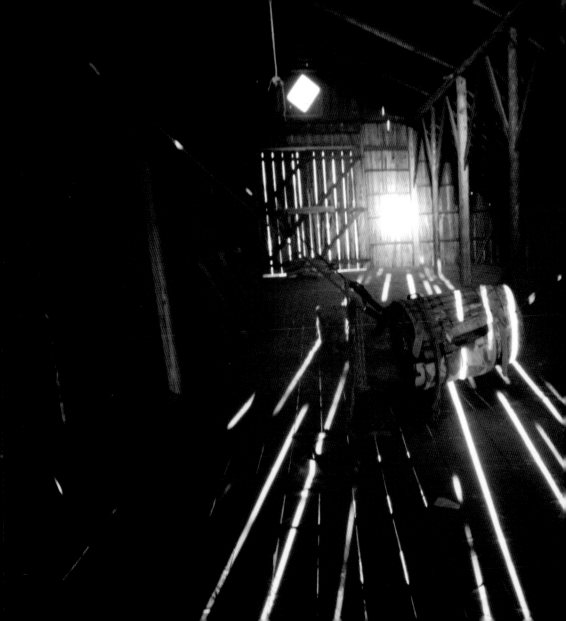

THE LOFT IN MOST BARNS
IS USUALLY WHERE THE
RANCH PLAYROOM IS
LOCATED. THE BARNS
ARE OFTEN BIGGER
THAN THE RANCH
HOUSE. KIDS LIKE TO
PLAY BASKETBALL AND
PRACTICE ROUGH STOCK
RIDING IN THE LOFT. OF
COURSE, MANY YOUNG
ROMANCES START IN THE
BARN LOFT AS WELL.

Miller Ranch
Big Piney, Wyoming

Previous page:
Bitterroot Stock Farm
Hamilton, Montana

Blue Moon
Jalama Ranch
Lompoc, California

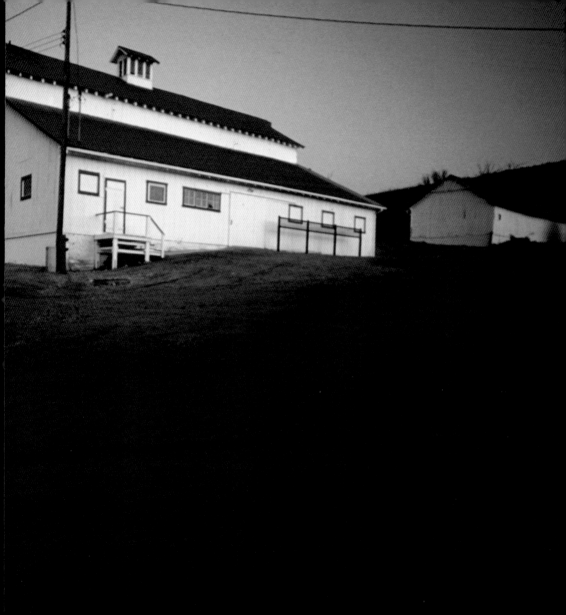

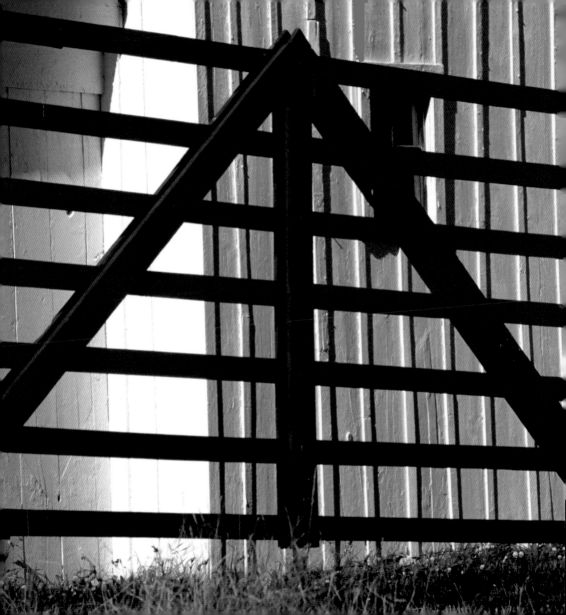

AS RANCHES GROW SO
DO THE BARNS AND THE
STRUCTURES AROUND
THE BARNS. MORE BARNS
AND SHOPS ARE BUILT
AND ALL KINDS OF
DOORS AND ALLEYWAYS
ARE ADDED UNTIL IT
BECOMES A MAZE OF
CORRALS AND SHOPS
AND GATES AND STORE
ROOMS. SOMETIMES IT
CAN BE SO CONFUSING
THAT ONLY THE RANCH
OWNER KNOWS WHERE
EVERYTHING IS AND HOW
TO GET THERE.

Grant-Kohrs Ranch
Deer Lodge, Montana

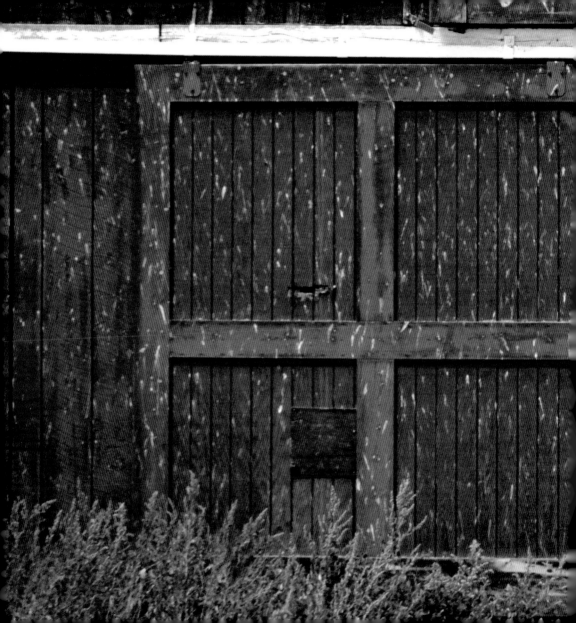

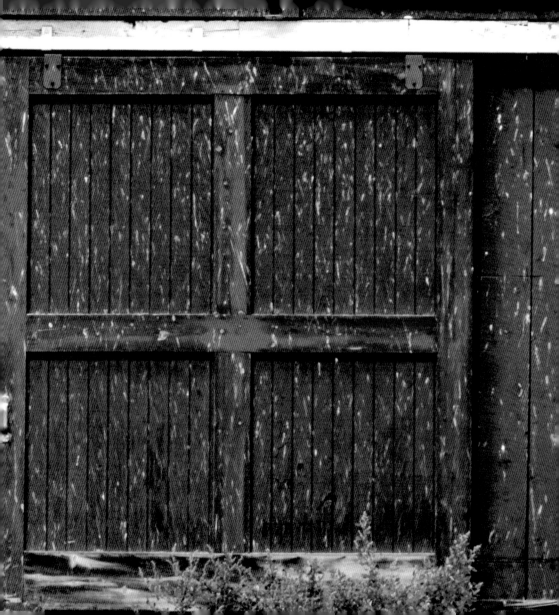

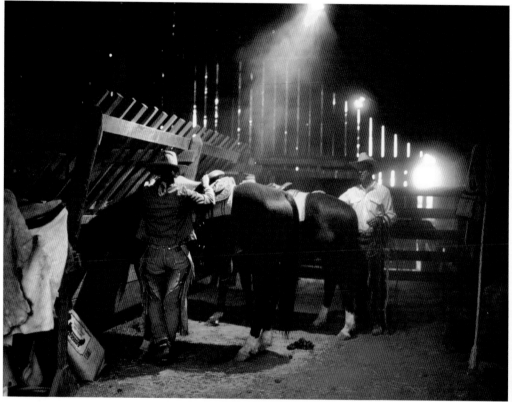

Claudia and Chet Vogt
Twin Creeks Ranch
Elk Creek, California

Twin Creeks Ranch

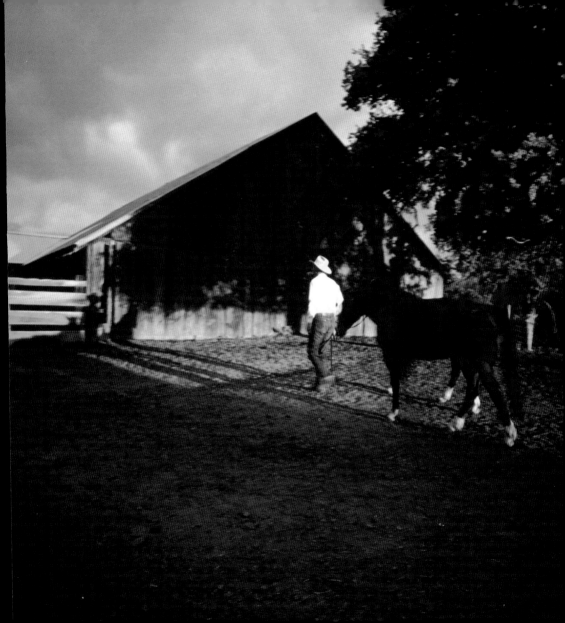

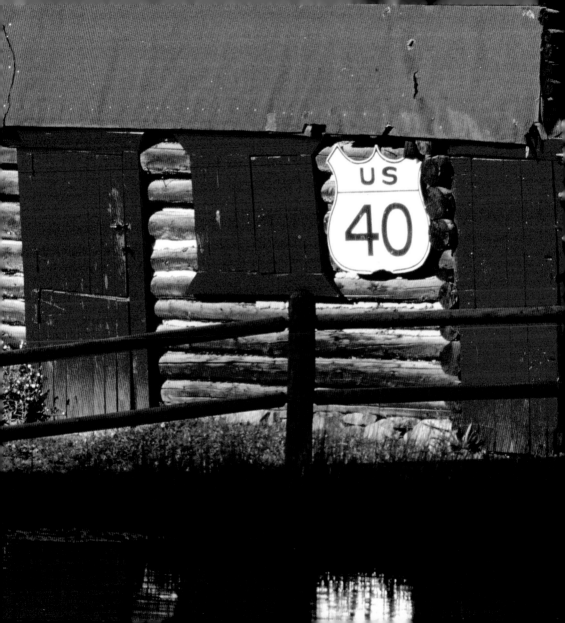

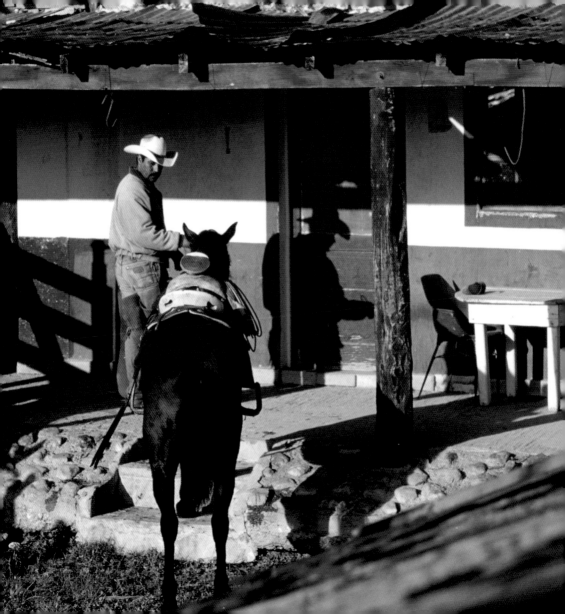

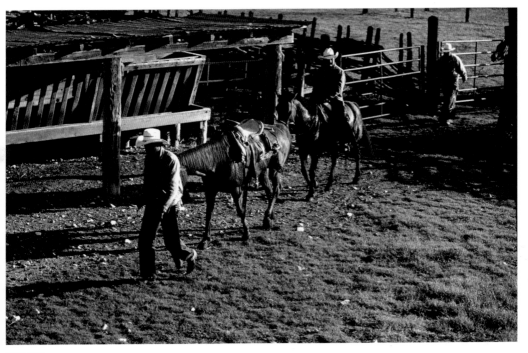

Saddle barn
Rancho El Fortin
San Bueno Ventura, Mexico

Rancho El Fortin

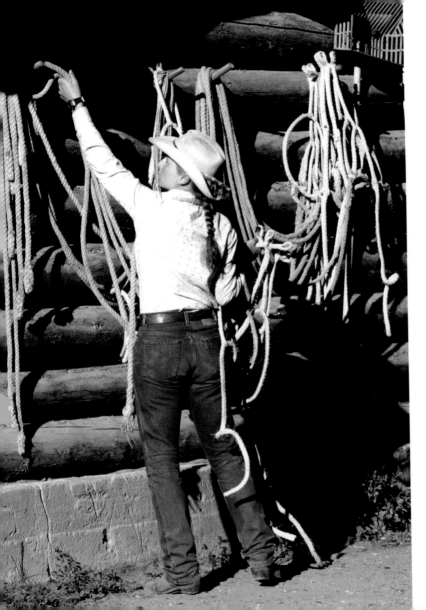

THE SIDE OF TH
BARN IS A GREAT
PLACE TO HANG
TACK WHERE IT I
EASY TO GET.

Elkhorn Guest Ranch
Gallatin Gateway, Montana

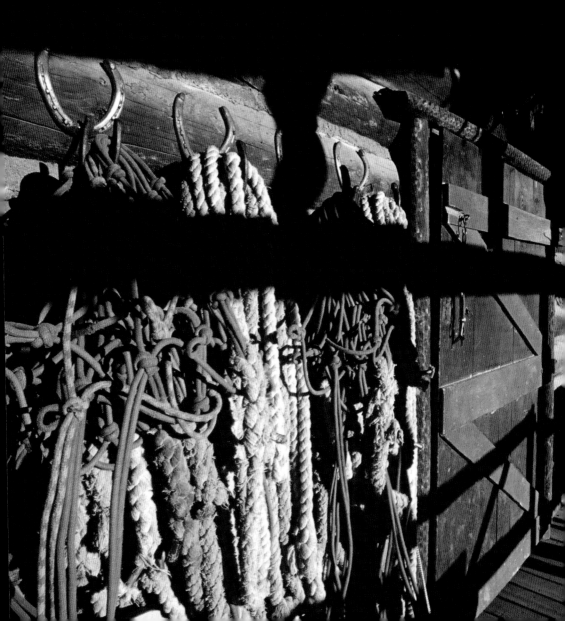

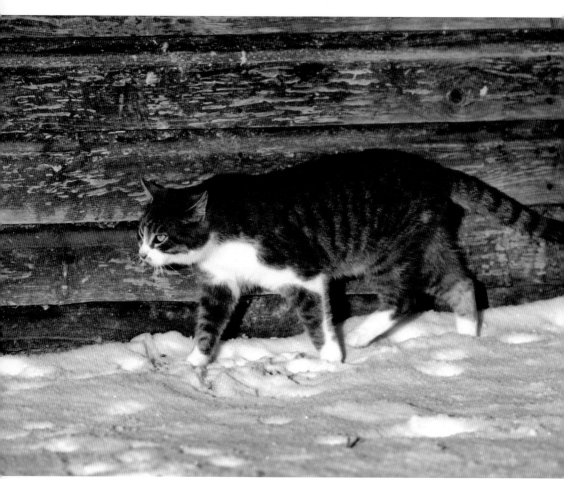

Vermedahl Ranch
Polson, Montana

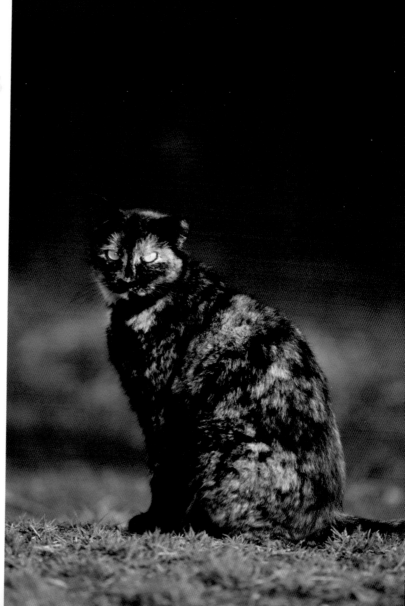

THE CATS ARE
THERE TO WORK.
THEY HUNT
THE MICE AND
OTHER NASTY
CRITTERS THAT
TRY TO INVADE
THE BARN.
SOMETIMES THEY
JUST SHOW UP
FROM UNKNOWN
PLACES. MAYBE
THEY GET
TIRED OF THE
NEIGHBOR'S BARN
AND DRIFT OVER
TO SEE HOW THE
HUNTING IS.

T Cross Ranch
Dubois, Wyoming

65

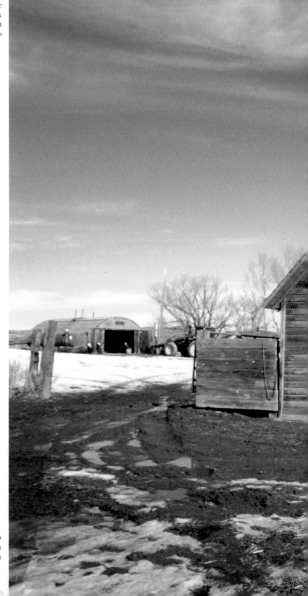

Royce Hanson saddling up
Maggie Creek Ranch
Elko, Nevada

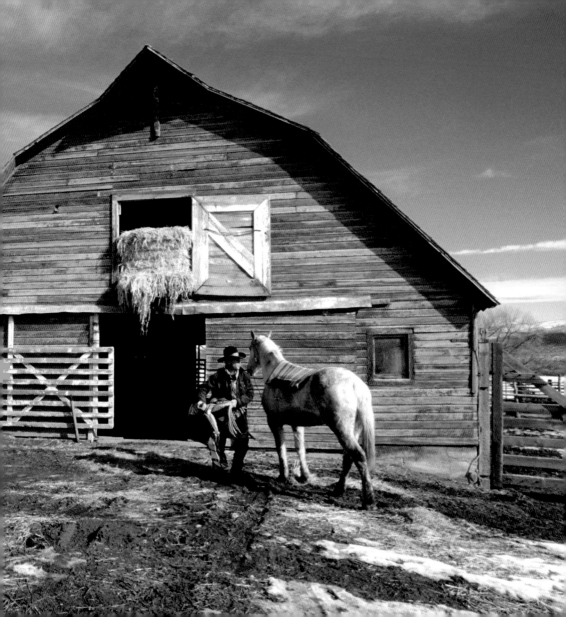

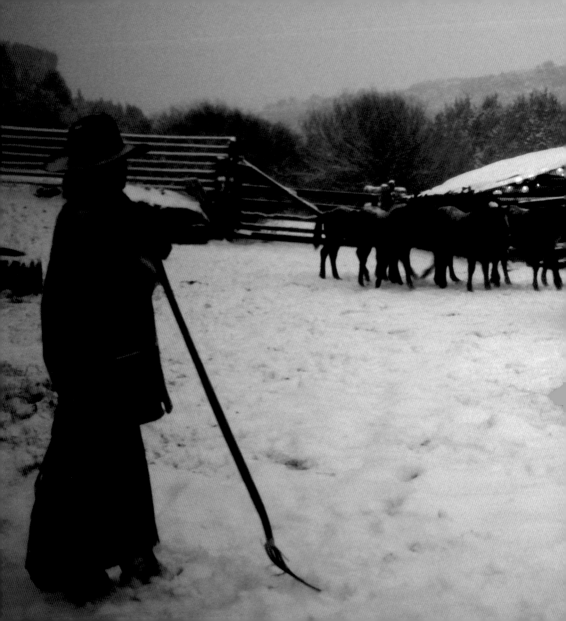

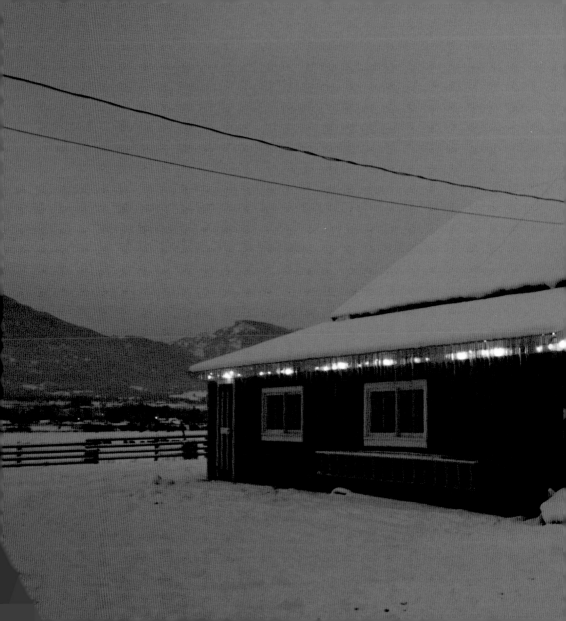

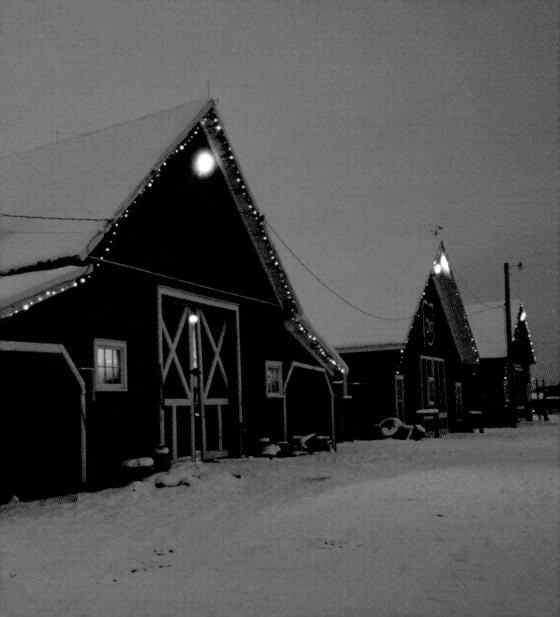

Previous pages:
Kevin Chapin
Diamond A Ranch
Jarbridge, Nevada

Christmas lights
Bitterroot Stock Farm
Hamilton, Montana

Monte Funkhouser and Keith Hill
sorting cattle
Bar Horseshoe Ranch
Mackay, Idaho

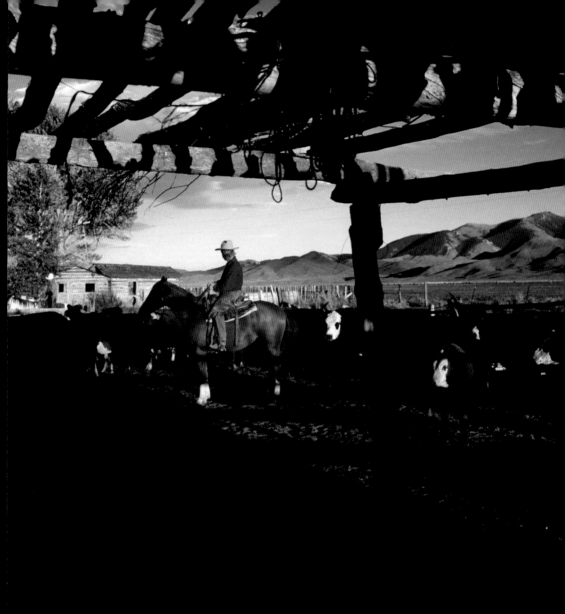

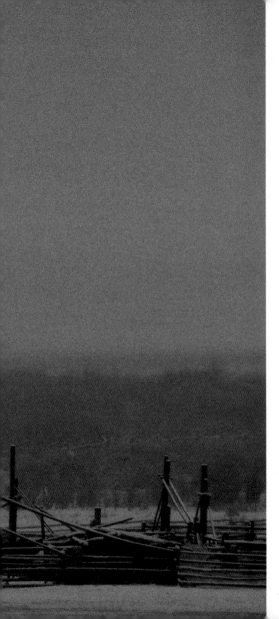

Winter Storm
Powers Ranch
Leadore, Idaho

Powers Ranch

Shoeing shed
Eatons' Guest Ranch
Wolf, Wyoming

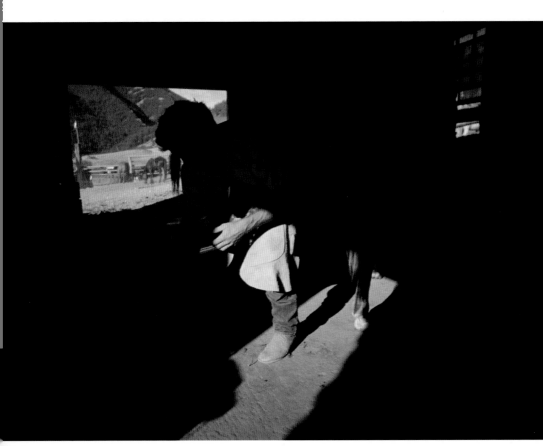

Farrier
Eatons' Guest Rnach
Wolf, Wyoming

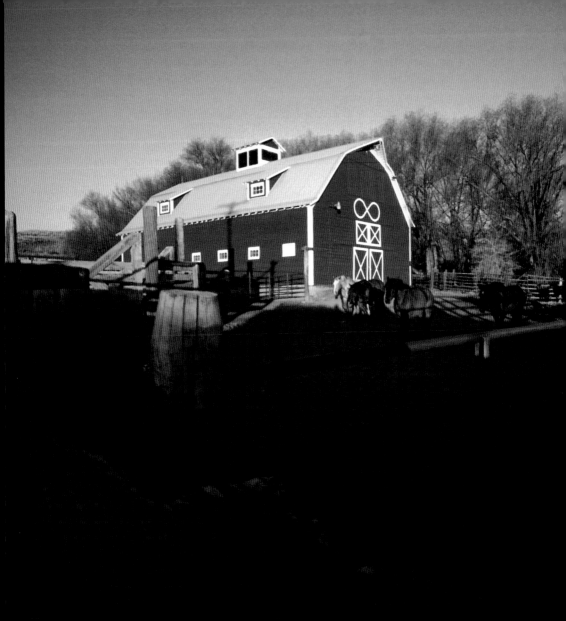

Barns

NOTHING LOOKS BETTER
THAN A WELL MAINTAINED
BARN. IF THE ROOF GETS
PAINTED AND THE BOARDS
ARE NAILED BACK IN PLACE,
IT CAN STAND FOR ANOTHER
HUNDRED YEARS.

Selkirk Ranch
Dillon, Montana

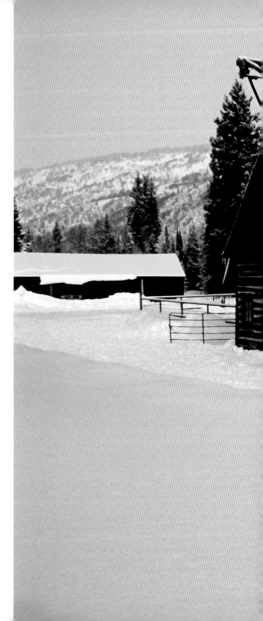

LOG BARNS SYMBOLIZE
THE WEST. LOGS WERE
FREE AND THE BARNS WERE
BUILT BY HAND. IN THE
ROCKY MOUNTAINS THEY
WERE THE FIRST BARN OF
CHOICE. WHEN EASTERNERS
AND EUROPEANS ARRIVED
WITH MORE MONEY, THE
RANCHERS WERE ABLE TO
PURCHASE MILLED LUMBER
AND TIMBER. THEN BARN
BUILDERS CAME AND SOON
BARNS STARTED TO LOOK
LIKE THEIR EASTERN
COUNTERPARTS.

Marvine Ranch
Meeker, Colorado

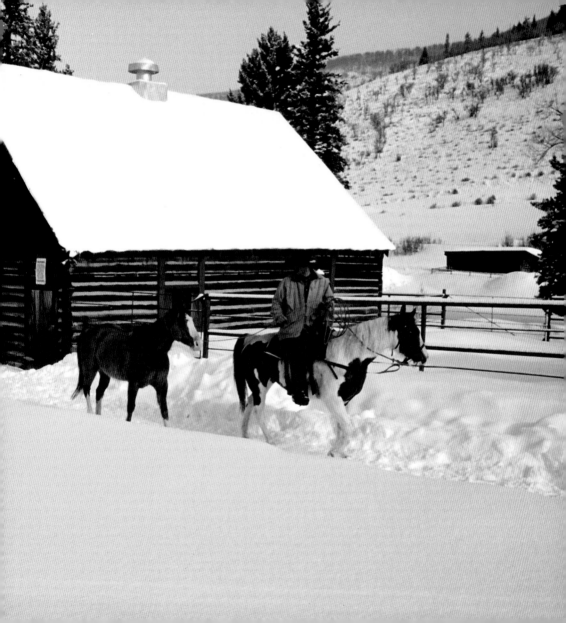

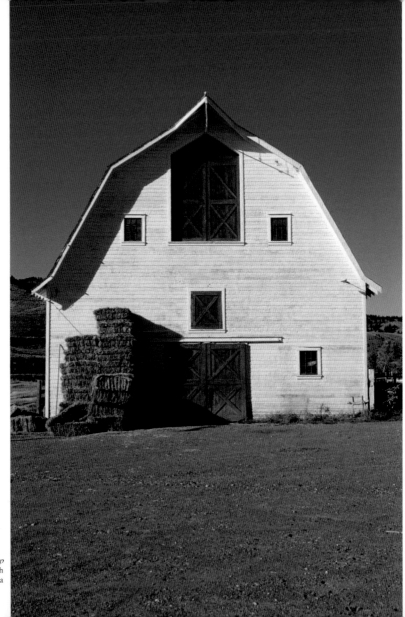

White Camp
CA Ranch
Three Forks, Montana

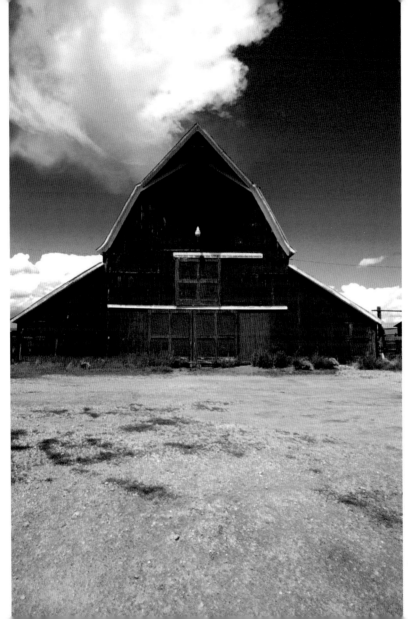

Centennial Livestock Ranch
Horse Prairie, Montana

Pride

THE BARN BECAME A
SYMBOL OF PRIDE FOR THE
RANCH. IT REPRESENTED
THE PERSONALITY OF
THE RANCH; IT WAS THE
BUILDING THAT PEOPLE
KNEW ABOUT AND TALKED
ABOUT. THE HORSE PRAIRIE
RANCH BARN IS PAINTED
ON THE RANCH GATE AND A
TINY REPLICA OF THE BARN
IS USED AS THE MAILBOX.
THE CREW PROUDLY SITS ON
HORSEBACK FOR A RANCH
PORTRAIT IN FRONT OF THE
BARN.

Horse Prairie Ranch
Horse Prairie, Montana

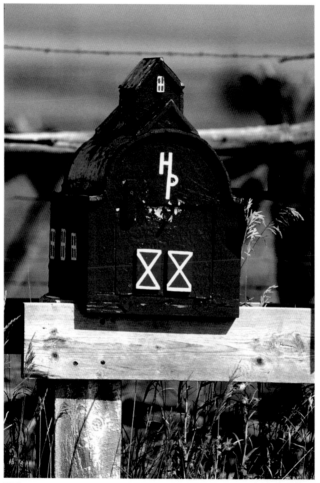

Mailbox
Horse Prairie Ranch
Horse Prairie, Montana

Crew
Horse Prairie Ranch
Horse Prairie, Montana

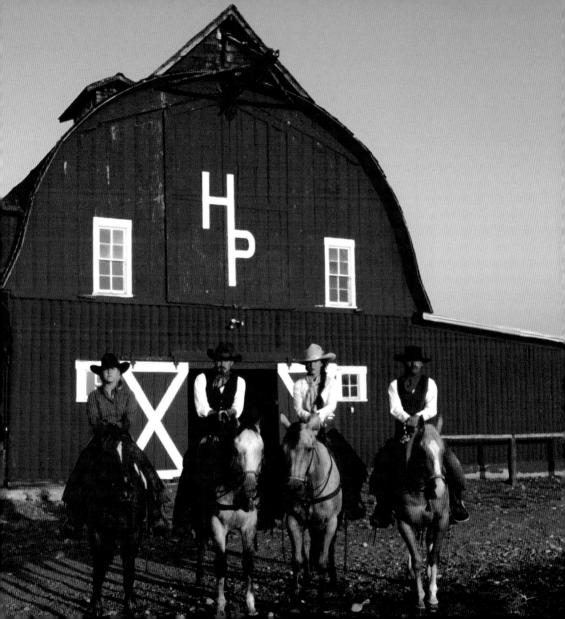

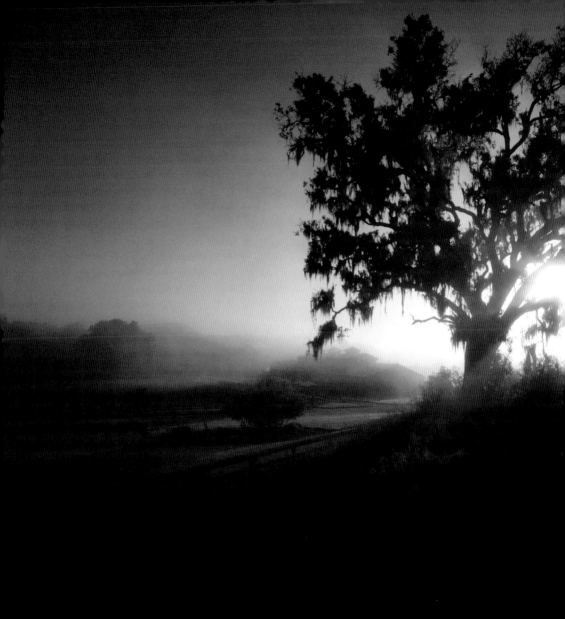

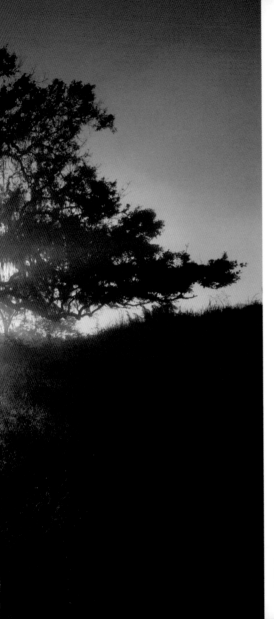

Early Morning Fog
Horse barn
Santa Lucia Preserve
Carmel, California

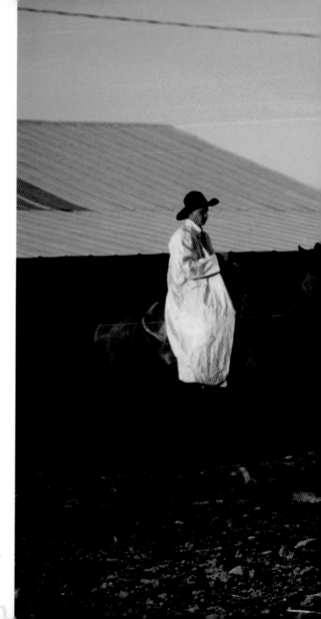

Going to Work
Veale Ranch
Breckenridge, Texas

Veale Ranch

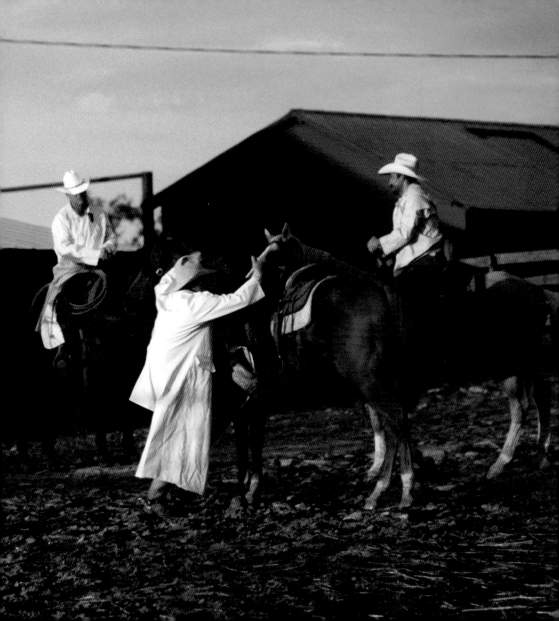

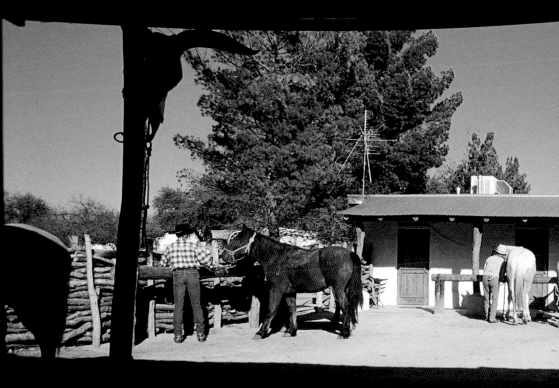

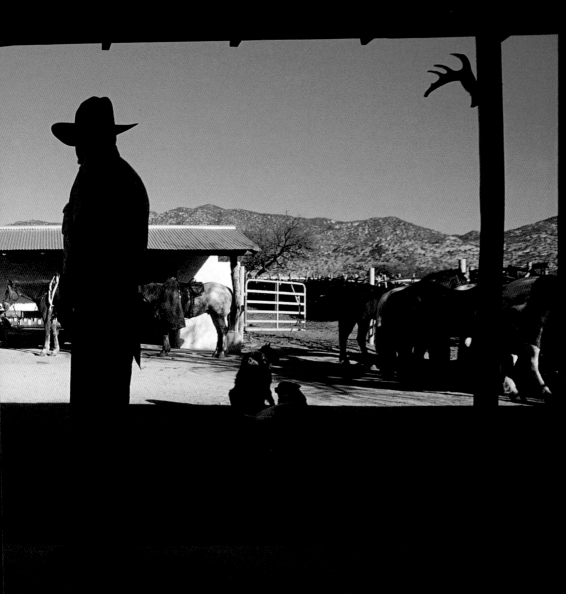

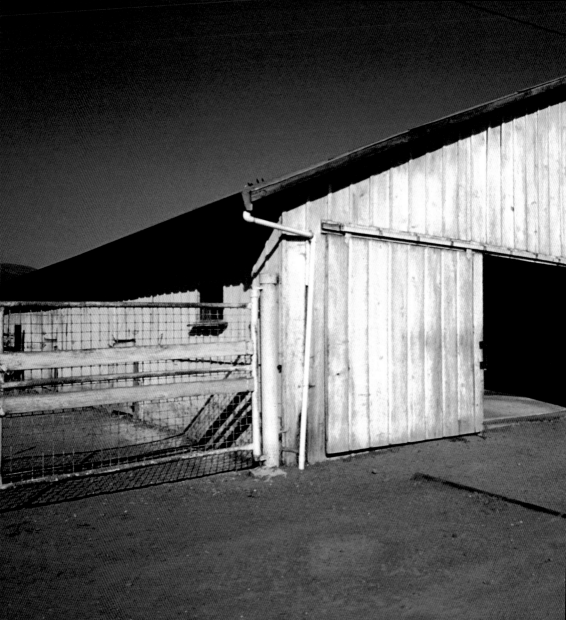

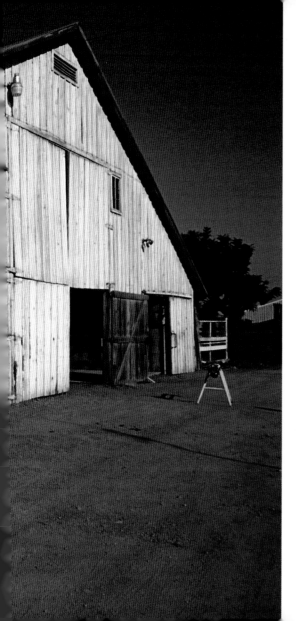

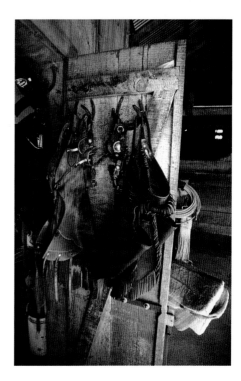

THE DUNN RANCH BARN IS OVER
100 YEARS OLD. TODAY IT IS USED
FOR HOUSING CUTTING HORSES,
WORKING COW HORSES, AND
ROPE HORSES AS WELL AS A FEW
SADDLE HORSES. THE RANCH
HAS CHANGED FROM PRIMARILY
A CATTLE OPERATION TO A
PERFORMANCE HORSE, WINERY,
AND CATTLE OPERATION.

Dunn Ranch
Hollister, California

Previous page:
Bellota Guest Ranch
Tucson, Arizona

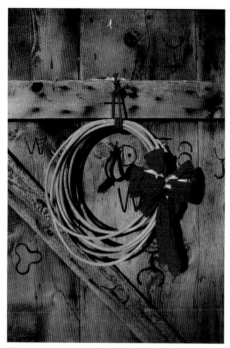

Christmas
Bar Horseshoe Ranch
Mackay, Idaho

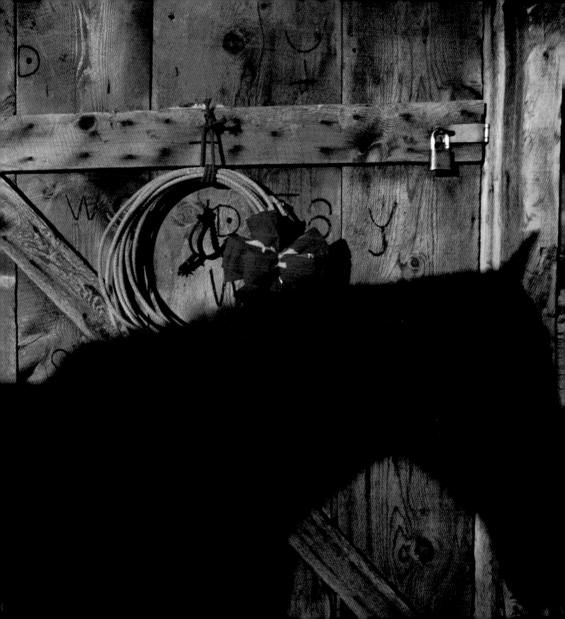

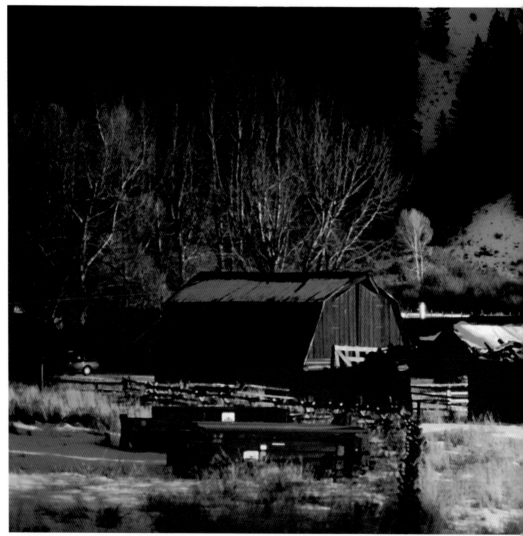

Walton Ranch
Jackson, Wyoming

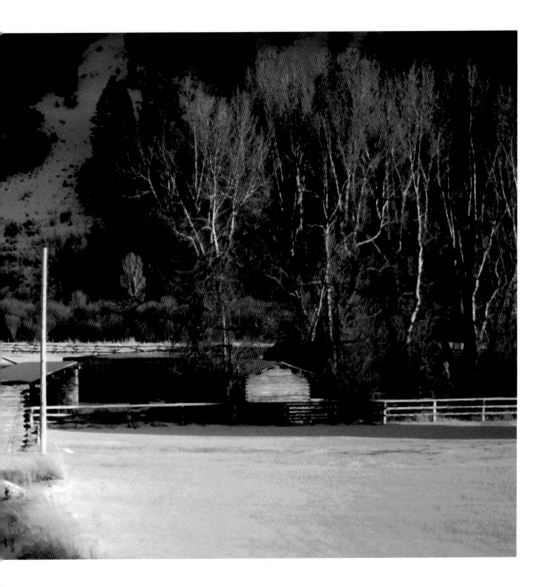

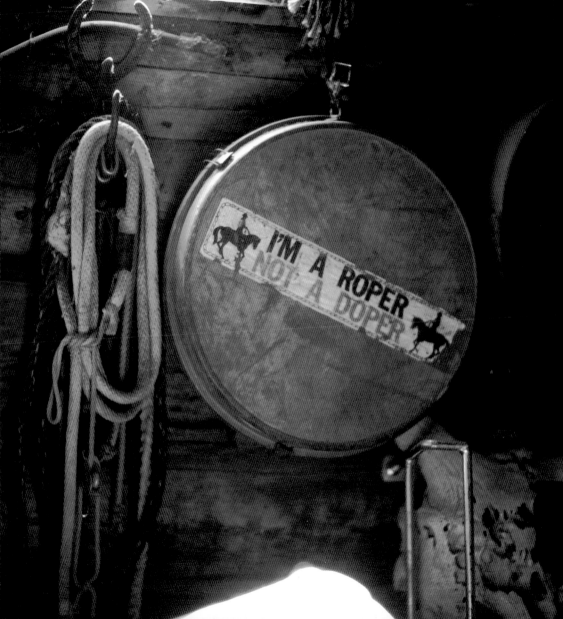

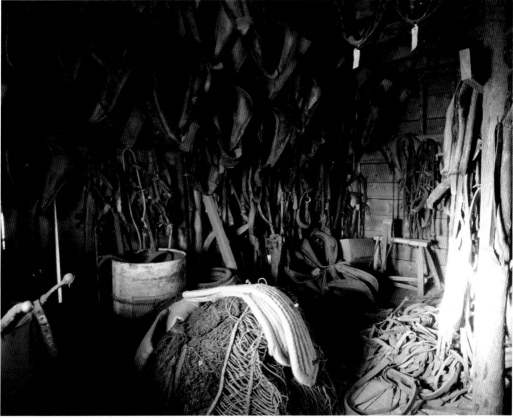

Rope can with 1970s bumper sticker
Miller Ranch
Big Piney, Wyoming

Old harnesses and fly nets from another era
Miller Ranch
Big Piney, Wyoming

Miller Ranch

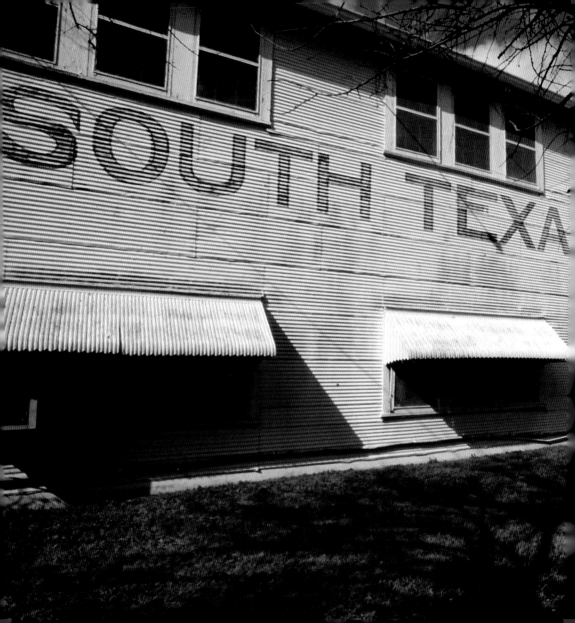

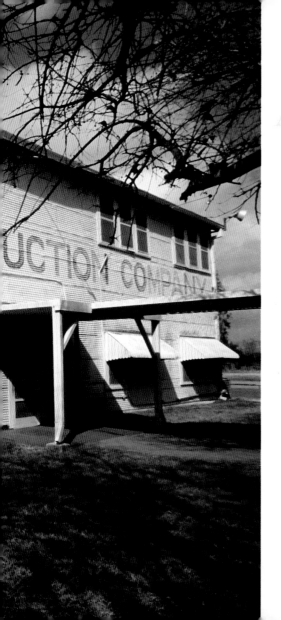

Auction Barn

THIS IS THE GREAT COMMUNITY GATHERING PLACE IN MOST SMALL RANCH TOWNS ACROSS THE WEST AND MOST OF CATTLE COUNTRY. THE AUCTION BARN IS WHERE MOST SMALL RANCHERS GET PAYCHECKS, DRINK COFFEE WITH NEIGHBORS, AND CATCH UP ON THE WEATHER FORECASTING AND ALL THE LOCAL NEWS. SOME HAVE GREAT RESTAURANTS OR JUST A LUNCH SPOT.

Auction barn
Alice, Texas

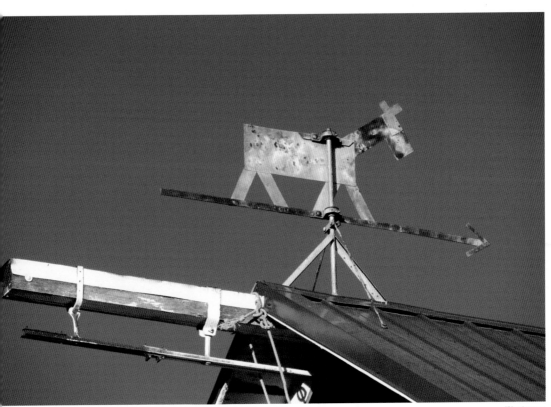

ng
Creek Ranch
California

Weathervane
Eatons' Guest Ranch
Wolf, Wyoming

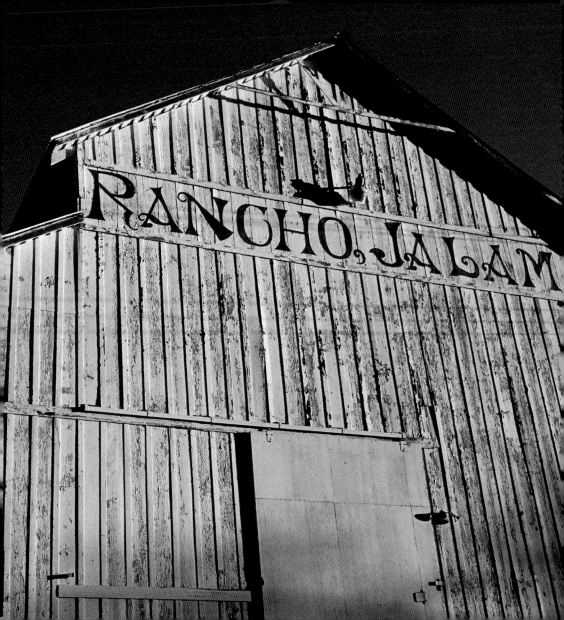

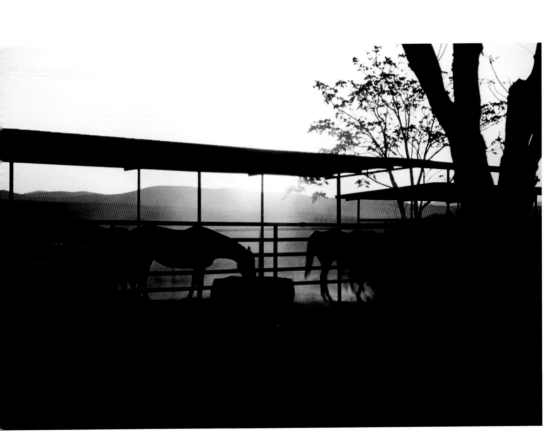

barn
a Ranch
oc, California

Horse sheds
Jack Ranch
Paso Robles, California

Misty Morning
South Glacier Park, Montana

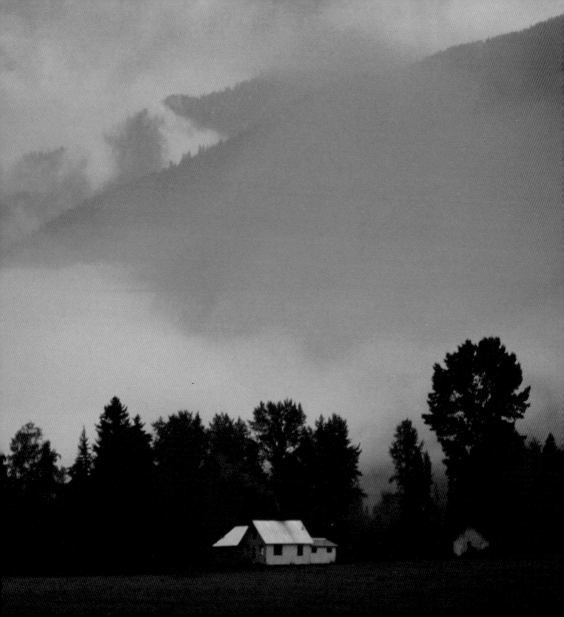

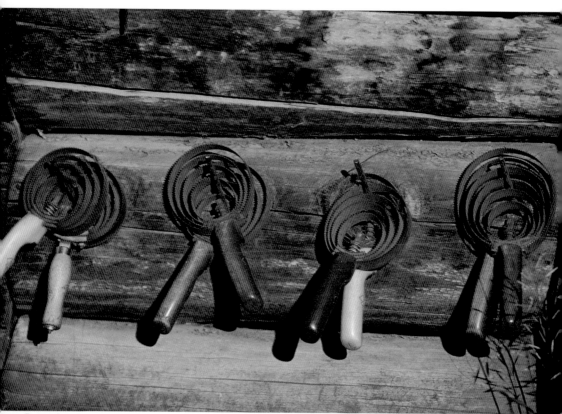

Curry combs
Barn wall
Elkhorn Guest Ranch
Gallatin Gateway, Montana

Brands on barn
Bar Horseshoe
Mackay,

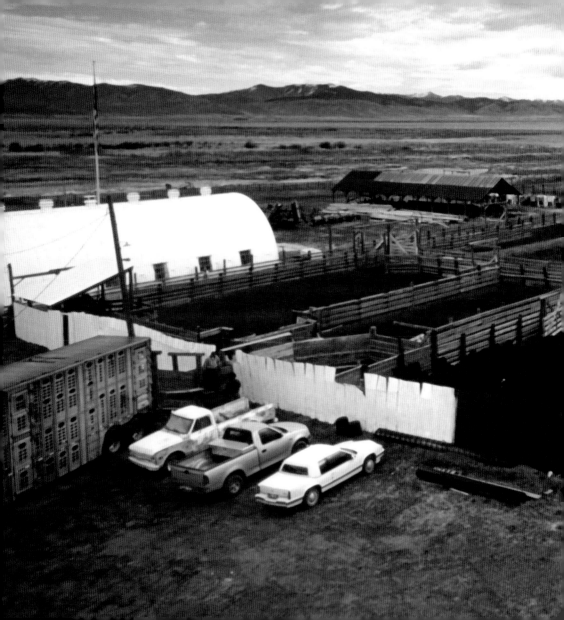

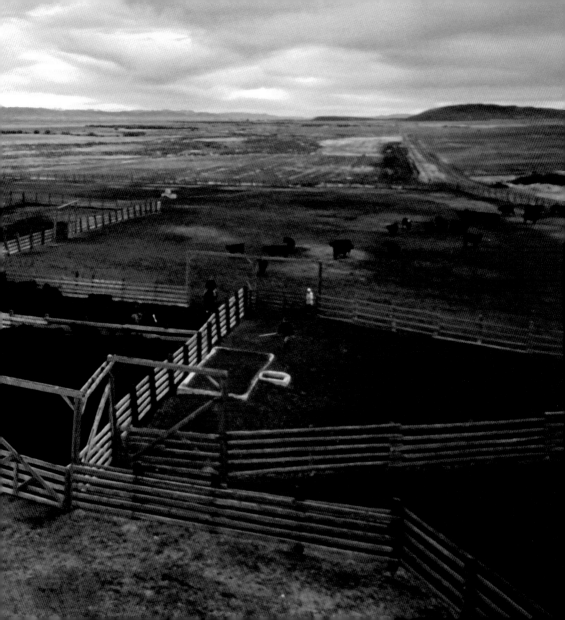

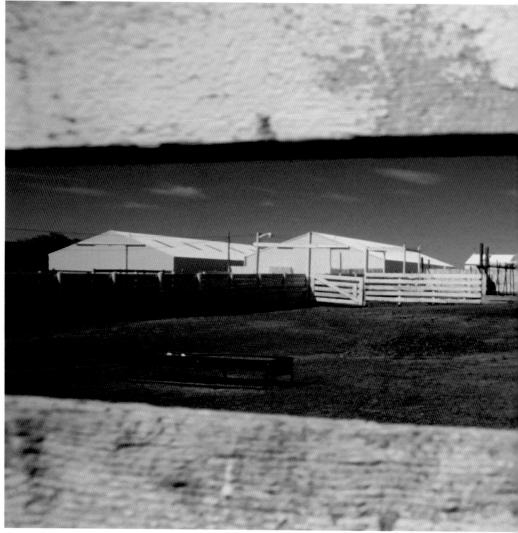

Horse corrals and barns
Binion Ranch
Jordan, Montana

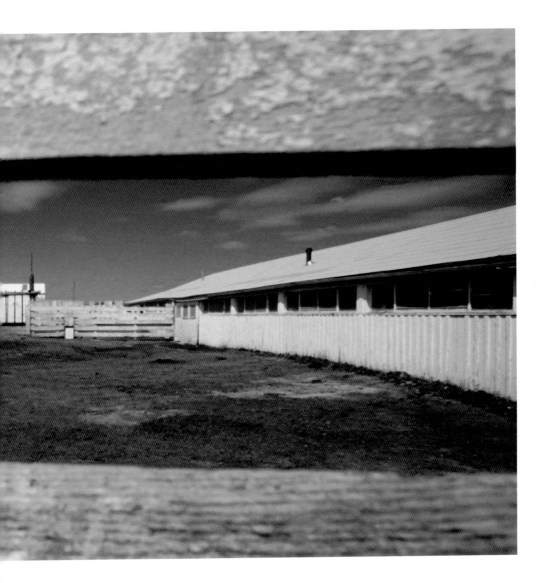

Relocation

LIKE ON SO MANY RANCHES
THESE BARNS ARE
GONE. THE NEW OWNER
REORGANIZED THE RANCH
TO SUIT HIS NEEDS. THIS
HAS HAPPENED SINCE THE
BEGINNING OF TIME. BARNS
HAVE BEEN MOVED OR
RELOCATED TO DIFFERENT
SPOTS ON THE RANCH OR
TO DIFFERENT RANCHES.
IN THE OLD DAYS THEY
WERE MOVED BY A TEAM
OF HORSES, OX MULES,
OR A WAGON OR SLEIGH
IN THE WINTER. A LOG
BARN WAS OFTEN SIMPLY
DISASSEMBLED AND THEN
REASSEMBLED AGAIN AT A
NEW LOCATION.

Tack room & horse barn
Bar 13 Ranch
Mackay, Idaho

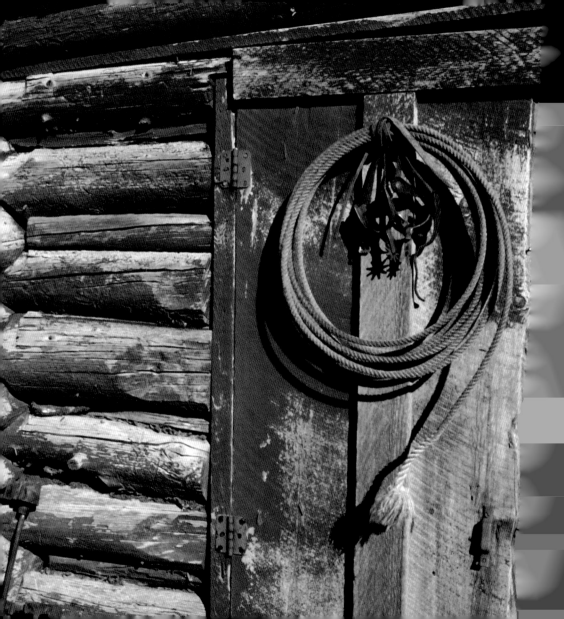

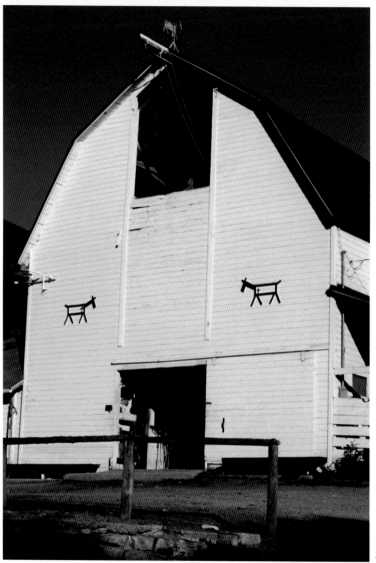

Horse barn
Eatons' Guest Ranch
Wolf, Wyoming

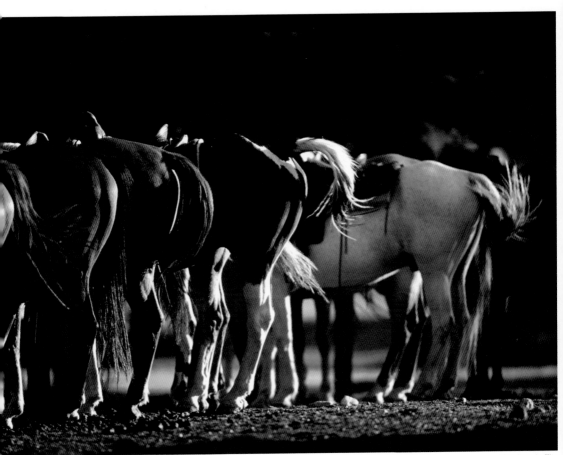

Swishing the Flies
Eatons' Guest Ranch
Wolf, Wyoming

Eatons' Guest Ranch

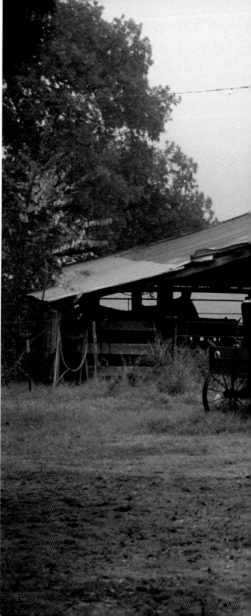

Barn too Small
Horseshoeing outdoors
Saunders Ranch
Weatherford, Texas

Arnold Ranch
Crockett, Texas

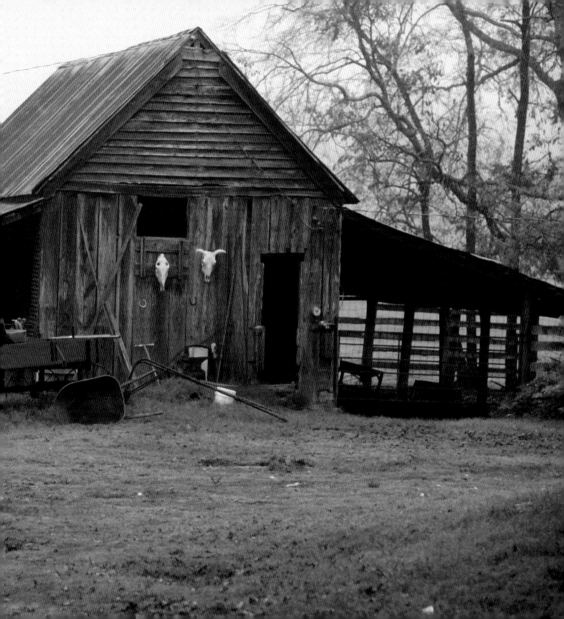

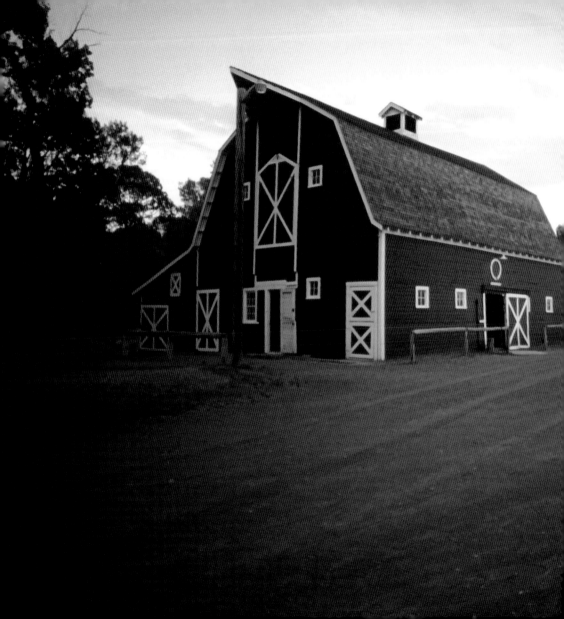

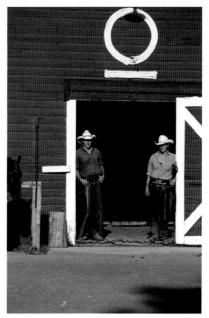

Ranch Brand
Brand made from big pieces of white rope
Circle Bar Guest Ranch
Utica, Montana

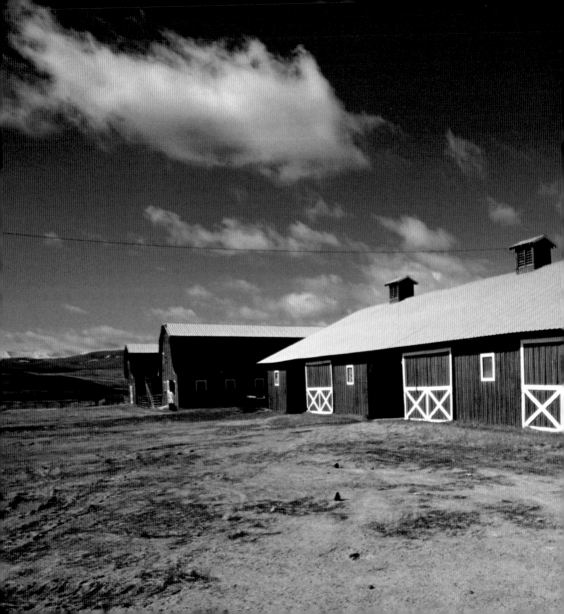

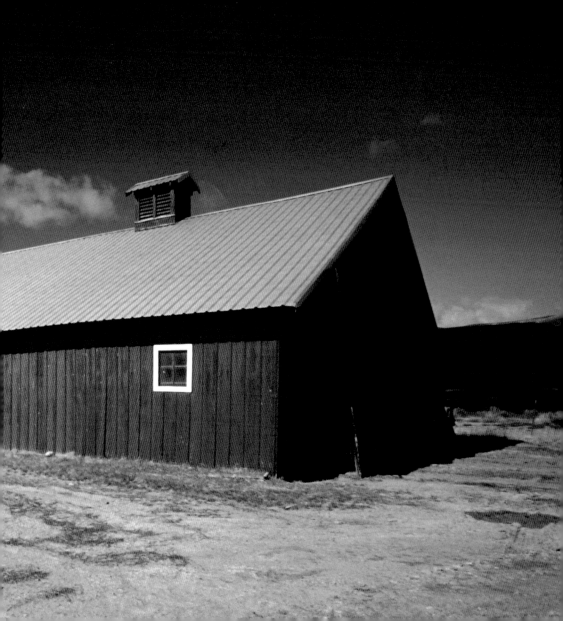

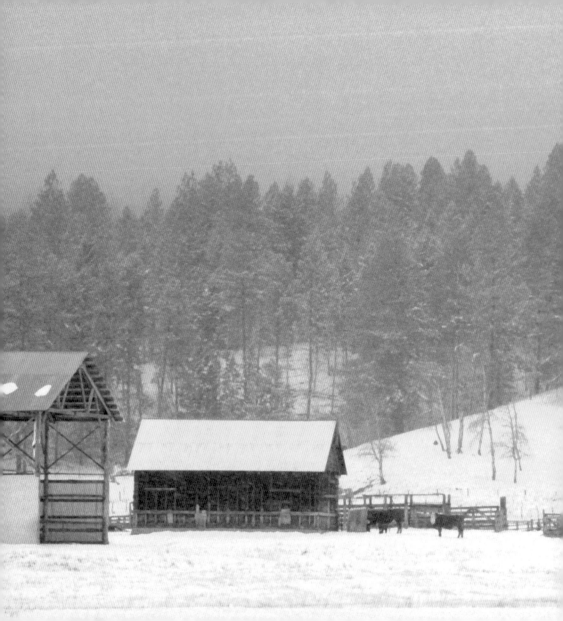

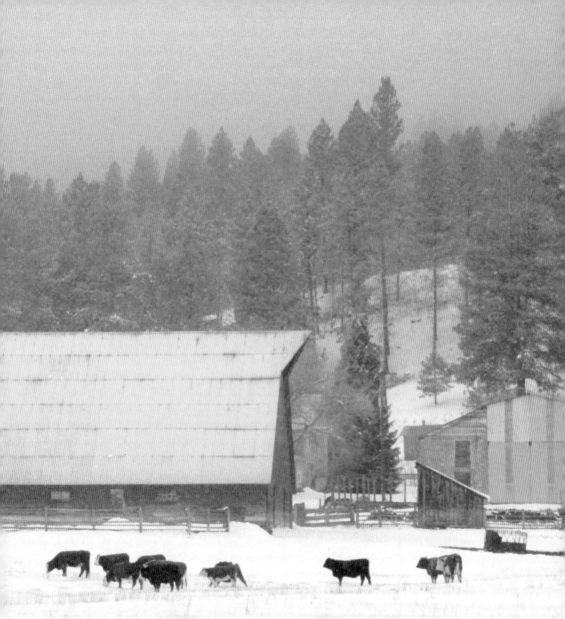

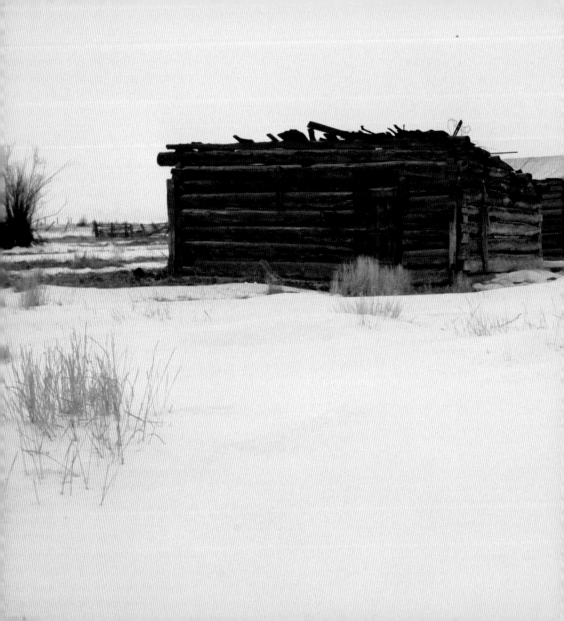

WINTER'S CHILL SETTLES IN
QUICKLY ON THE OLD BAR
HORSESHOE RANCH. MOST
OF THESE BARNS WERE
TAKEN DOWN AND USED
TO BUILD A NEW HOME.
RECYCLED LOGS AND BARN
WOOD ARE VERY POPULAR
IN THE WEST. MAKING NEW
BUILDINGS OUT OF OLD
LOGS AND LUMBER IS A
WONDERFUL PRACTICE. IT
PRESERVES THE HISTORIC
CHARACTER OF THE WOOD.

Bar Horseshoe Ranch
Mackay, Idaho

Previous pages:
Old Yellowstone Stage Stop
Matador Ranch
Dillon, Montana

Red barn
Cascade, Idaho

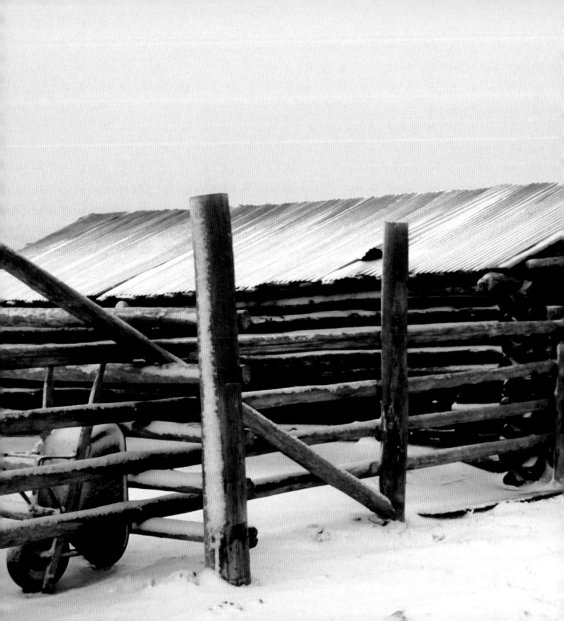

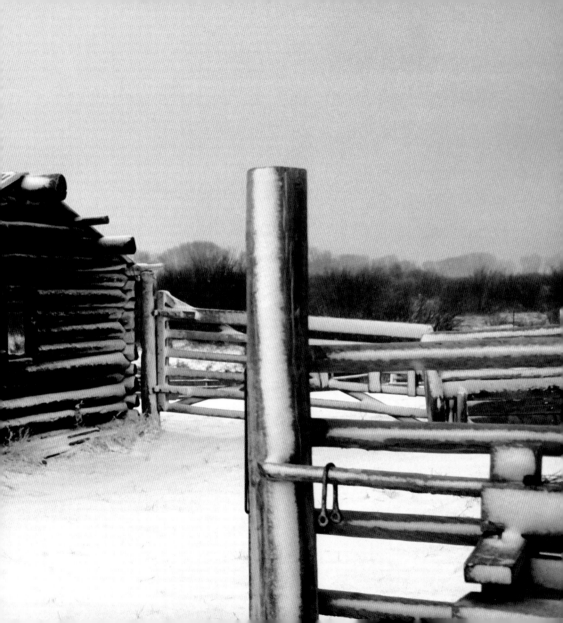

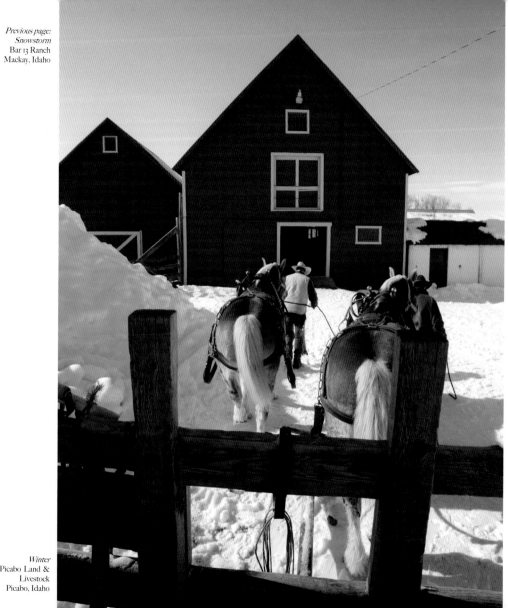

Winter
Picabo Land &
Livestock
Picabo, Idaho

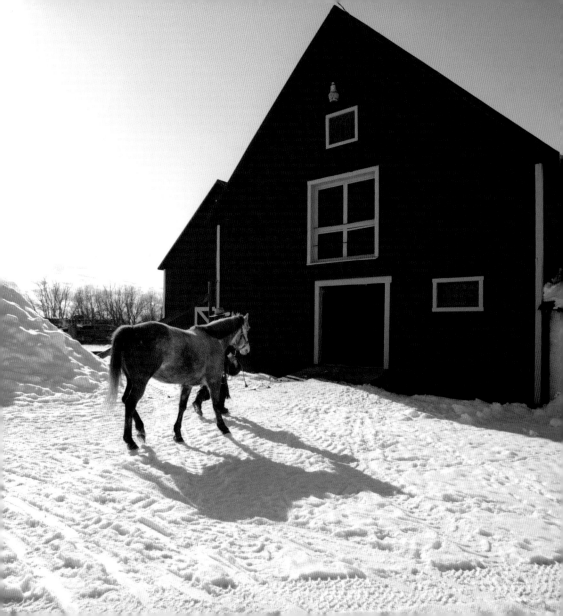

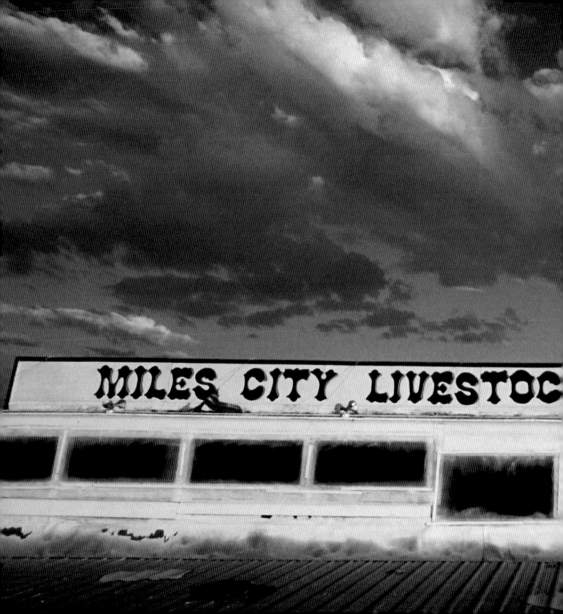

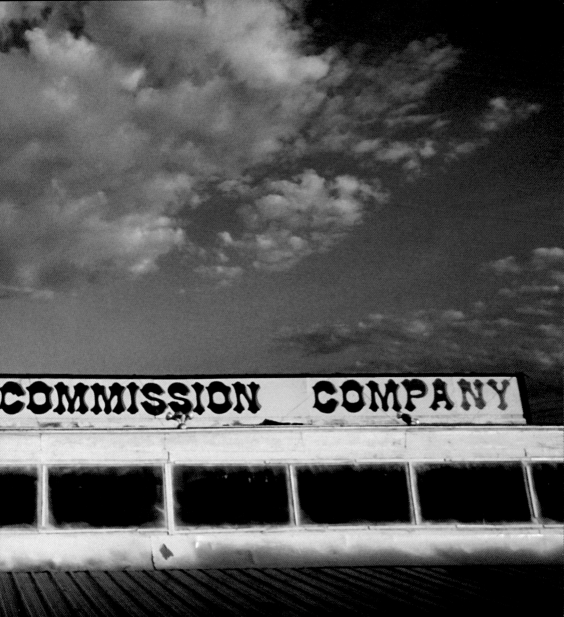

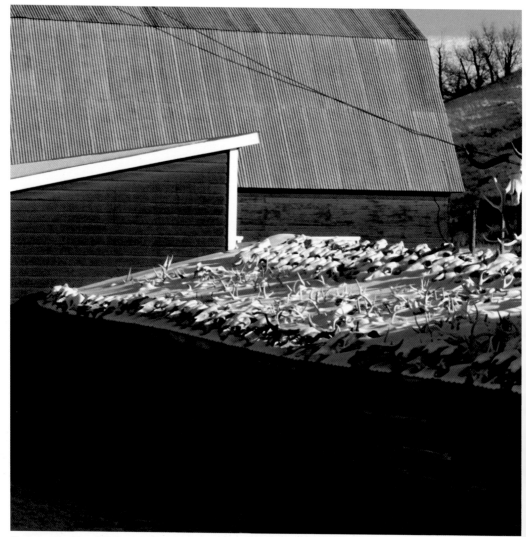

Deer horns, cow and horse skulls decorate the barn roof
Cornwell Ranch
Glasgow, Montana

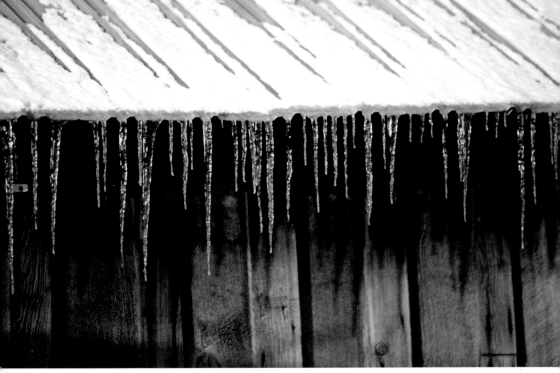

Icicles
Hall Ranch
Bruneau, Idaho

Hall Ranch

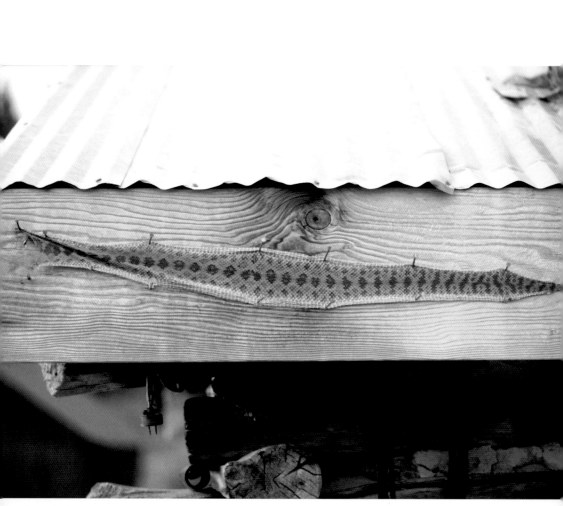

Rattlesnake skin
Bonnie Ranch
Bruneau, Idaho

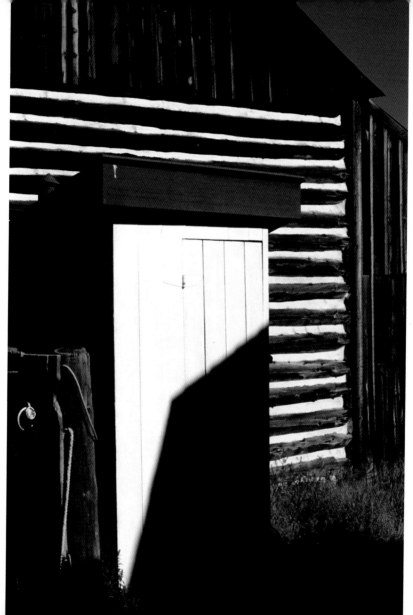

Barn outhouse
Grant-Kohrs Ranch
Deer Lodge, Montana

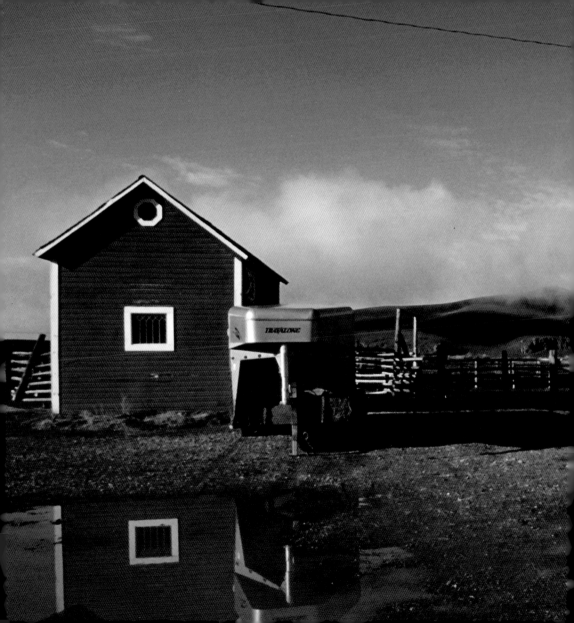

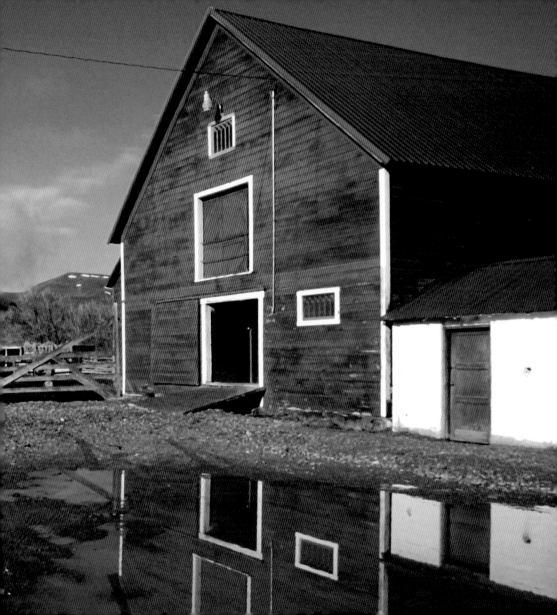

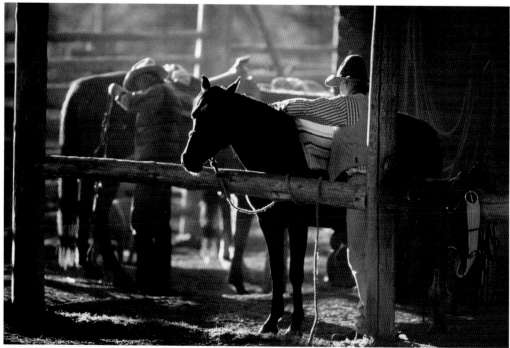

Saddling Up the Dude Horses
63 Guest Ranch
Livingston, Montana

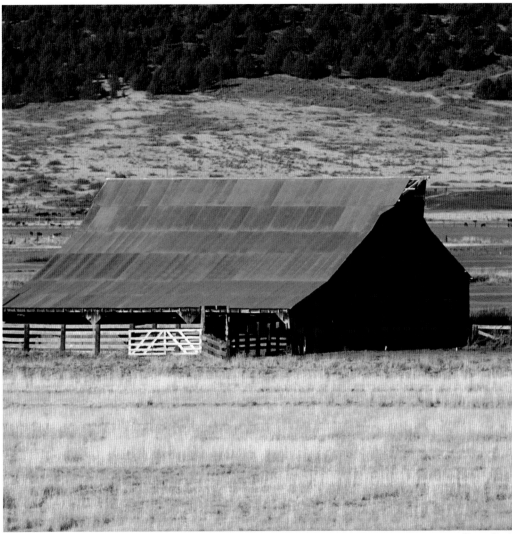

Flournoy Ranch
Likely, California

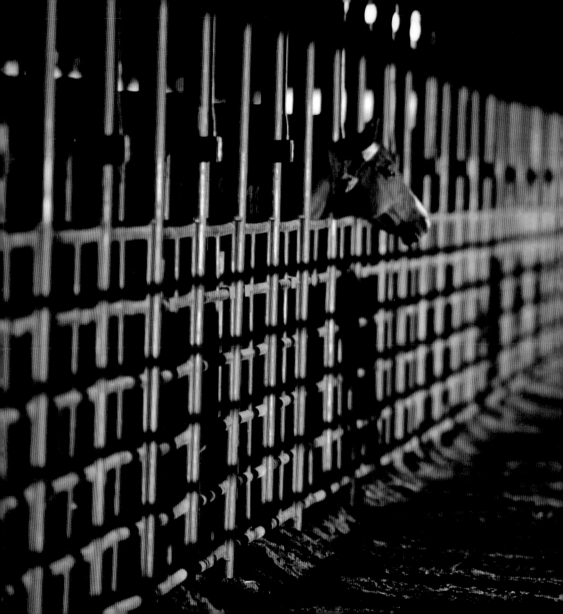

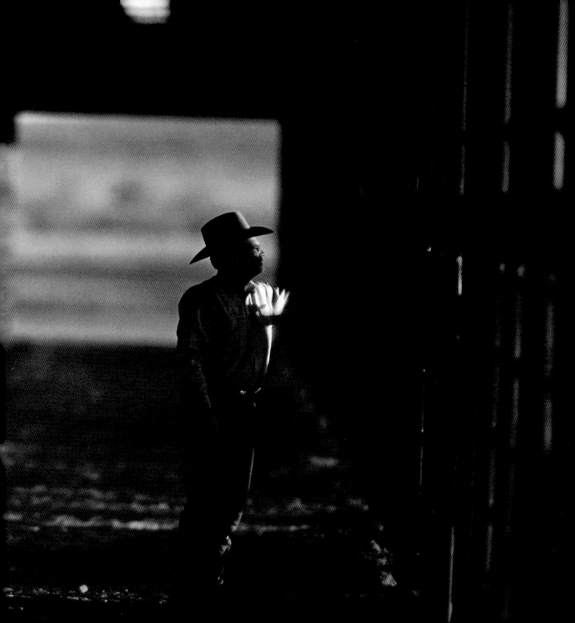

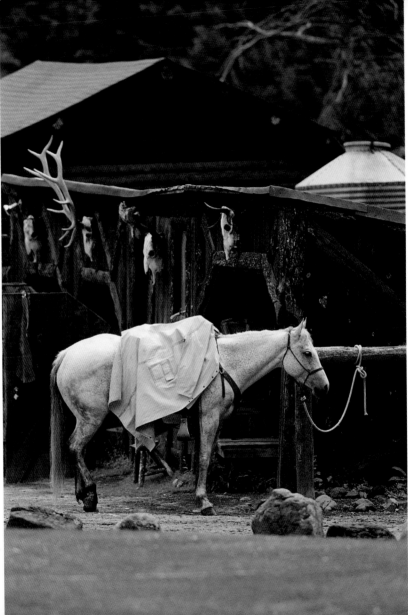

TECHNICAL NOTES

I use Kodak film and Canon cameras and lenses for all the photography in my books and in my commercial work as well. I use a variety of different cameras from Canon, mostly the EOS 1N and the 1V. As for lenses, I use the 300mm and 400mm f/2.8 IS USM and the 16-35mm and 28-70mm f/2.8L USM and 70-200mm f/2.8L USM zooms. I also use prime lenses like the 20mm f/2.8 USM, 35mm and 50mm f/1.4 USM whenever I can, which happens to be most of the time. This year I switched from using film cameras to digital cameras. It was a big move for me but once I did it I never looked back. With the help of some of my fellow photographers from the Canon "Explorers of Light" program like Clint Clemens, along with encouragement from Steve Inglima and David Metz of Canon, I am on my way. You can expect to see more great books shot with my new Canon digital cameras in the future.

All of the slide film for this project was processed at the BWC lab in Dallas, Texas. They have been processing the film for all of my books as well as the 35mm film for my regular assignments for the last thirteen years. We have a great working relationship, one that is essential in this line of work to maintain consistency and accuracy.

I am extremely lucky to have all the good people at Canon USA and BWC as a support team while I fly around the country on assignments. Without all of them my job would be much more difficult.

—David R. Stoecklein

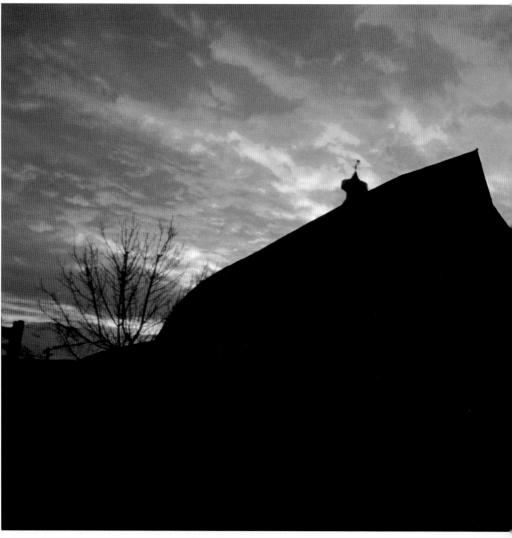

71 Ranch barn
Elko, Nevada

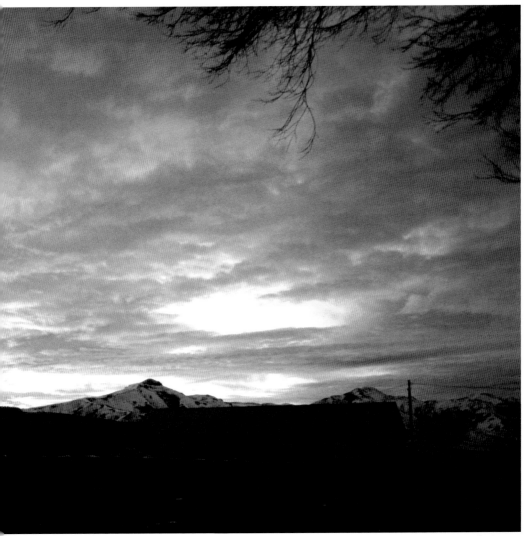

Previous page:
Grain barn
YO Ranch
Kerrville, Texas

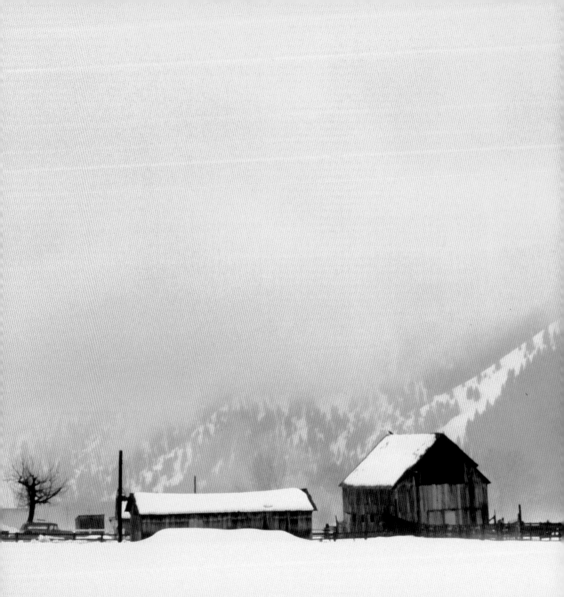

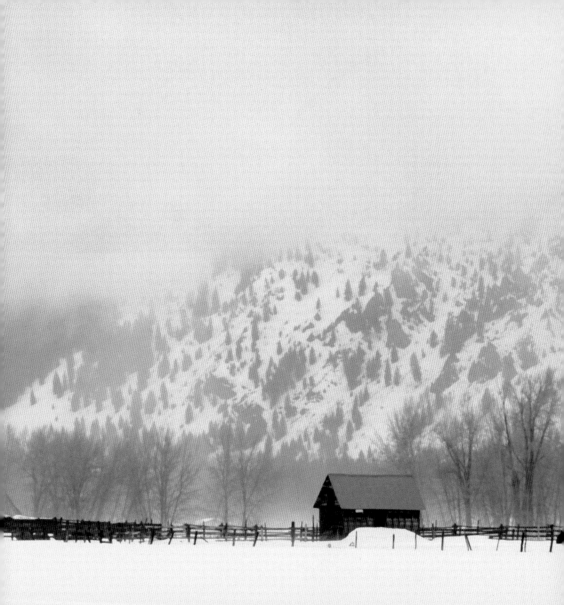

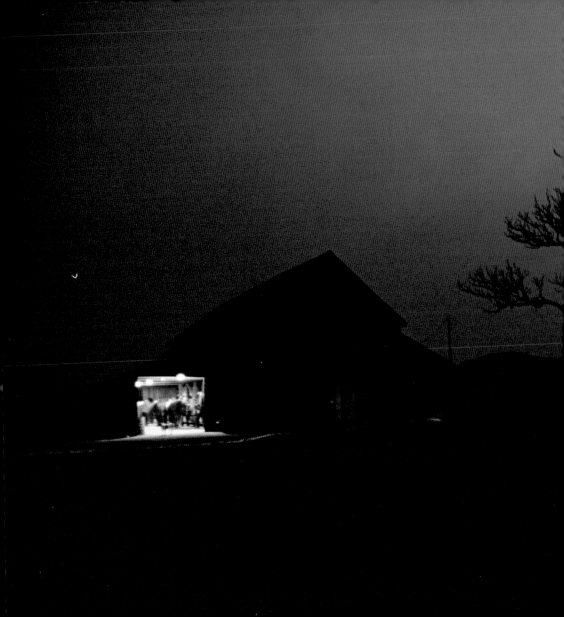

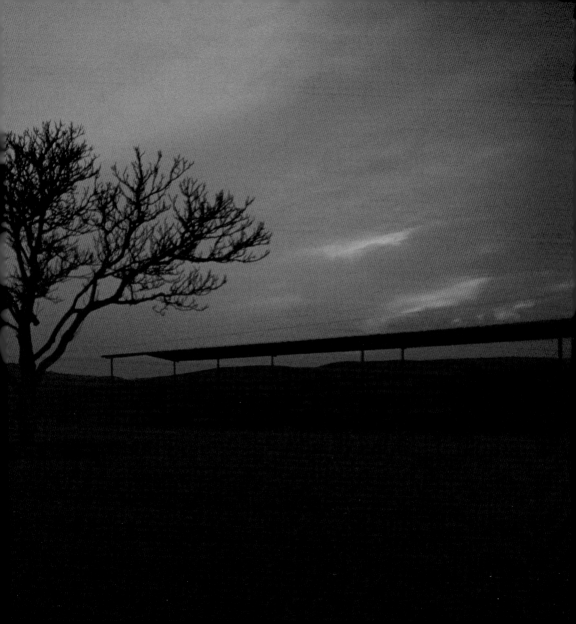

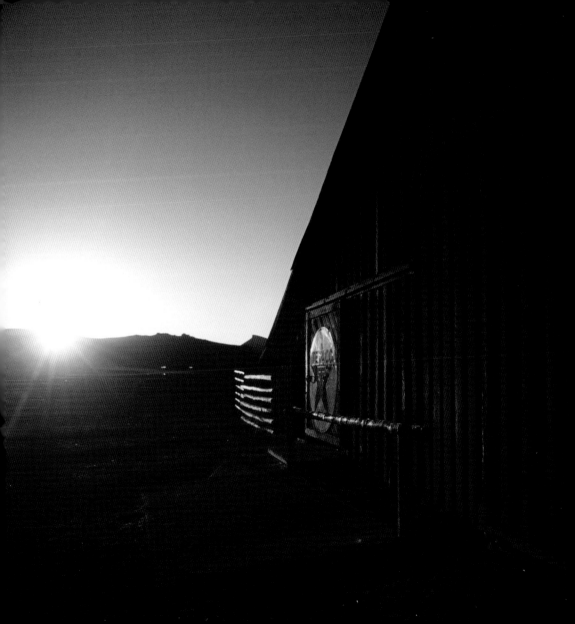

OTHER BOOKS BY STOECKLEIN PUBLISHING

THE WESTERN BUCKLE
THE COWBOY HAT
THE COWBOY BOOT
FLY FISHING IN IDAHO
RANCH STYLE
WAITING FOR DAYLIGHT
OUTHOUSES
CATTLE
WESTERN FENCES
COWBOY ETHICS
COWBOY WISDOM
CALIFORNIA MISSIONS
SADDLES OF THE WEST
THE AMERICAN QUARTER HORSE
THE HORSE DOCTORS
COWGIRLS IN HEAVEN
THE PERFORMANCE HORSE
LIL' BUCKAROOS
COW DOGS
SPIRIT OF THE WEST
THE AMERICAN PAINT HORSE
THE CALIFORNIA COWBOY
THE IDAHO COWBOY
COWBOY GEAR
THE MONTANA COWBOY
DON'T FENCE ME IN
COWGIRLS
THE TEXAS COWBOYS
THE WESTERN HORSE
SUN VALLEY IMAGES
SUN VALLEY SIGNATURES I, II, III

WWW.THESTOECKLEINCOLLECTION.COM

Previous pages:
Old ranch now gone to development
Highway 93
Ketchum, Idaho

Jack Ranch
Paso Robles, California

Susie Q Ranch
Picabo, Idaho